ART
FOR THE FUN
OF IT
a guide for teaching young children

peggy davison jenkins

PRENTICE
HALL
PRESS

New York London Toronto Sydney Tokyo Singapore

To that spring of pure creativity
that is within each and every child

Prentice Hall Press
15 Columbus Circle
New York, New York 10023

Published in 1986 by Prentice Hall Press
Originally published by Prentice-Hall, Inc.
Cover design and interior design by Dawn L. Stanley
Cover art and interior art by April Blair Stewart

Art for the Fun of It was previously published
as *Art Principles and Practices*.

PRENTICE HALL PRESS and colophons are registered
trademarks of Simon & Schuster Inc.

Library of Congress Cataloging-in-Publication Data

JENKINS, PEGGY DAVISON.
Art for the fun of it.

Bibliography: p.
Includes index.
1. Art—Study and teaching (Preschool) 2. Art—
Study and teaching (Primary) I. Title.
LB1140.5.A7J46 372.5′044 80-12050
ISBN 0-13-047241-7
ISBN 0-13-047233-6 (pbk.)

Manufactured in the United States of America

10 9 8 7 6 5

contents

5

6

7

8

9

10

PART TWO / ART PRACTICES, 95

11

13

Contents

preface

It's all been said before—and very well—by eloquent authorities, so why another book on children's art?

Because those who most need the information have not been able to find it readily and not without going to many books— finding philosophy in one, methods and materials in others. I am referring to the

- Busy mother of preschoolers.
- Harassed day care leaders.
- Student teachers studying and working at the same time.
- Parent education instructors in charge of so many cooperative preschools.
- Busy beginning teachers with so much to read and remember.
- Teachers of teachers who have to get across so much and need to do it in the most concise and practical way.

I played most of the above roles myself, and what I needed was not available, so I decided to create it myself—a single compre-

hensive manual that has both the important principles of art education and all the "how to" activities for the basic media.

As an educator of teachers, parents, and children, I saw my own art library grow by leaps and bounds, but I knew I could not expect this of the young parents and beginning teachers I was guiding. With their limited time and budgets, they needed a complete guidebook that was not overwhelming. It is my hope to have met that need.

So much more could have been included, especially in the areas of creativity, stages of development, and novel art activities, but only at the expense of producing one of those heavy thick books that turn busy people off.

For those whose resources do not limit them to one general art book, this one offers a good starting place because it has a solid organizational frame and suggests many authors that can fill in the framework where desired.

The many ways of using this book include parent meetings where the philosophy of art education needs to be explained and teacher training classes because it summarizes a vast amount of material. Instructors of teachers may find it useful as a basis for a course outline or for assignments and outside readings. The frequent references and extensive bibliographies tell the serious student where to find further information.

Part II can serve as a curriculum guide. Teachers can check out their art programs to see that there is a balance of the major art areas as listed in the table of contents. Parents can also use this section to make sure that there is a balance in the child's art experience, so that no area is neglected that might be satisfying.

Even though aimed at the young child, the essence of this book can be used wherever art is offered—hospitals, therapists' offices, Sunday schools, prisons, day camps and summer camps, Boy Scout, Girl Scout, and Campfire meetings, park and recreational centers, human potential classes, and senior citizen centers, to name a few. What is true and good for the young child is true and good for that child within all of us.

ACKNOWLEDGMENTS

My indebtedness is incalculable.

First and foremost, my appreciation goes to my family, without whose loving support this book would not have been possible. A heartfelt "thank you" to my mother, Peggy Davison, for encouragement, guidance, and typing, and to my husband and children for allowing me the needed hours in the day to accomplish this work.

The impulse to create the book began with my varied teaching experiences at Bellevue Community College in Washington. I extend warm thanks to all those teachers and colleagues, there and elsewhere, who have provided me with models and ideas. Special appreciation goes to Margaret Woods of Seattle Pacific University for the inspiration received in her master's program on creativity.

I am very grateful to the many authors who have had an impact on my professional life and thank all those whose names appear in this text and bibliographies. Special thanks to the publishers and authors who allowed me to reprint material from their books.

I am most appreciative of the vote of confidence and assistance I have received from editor Mary Kennan.

Peggy Davison Jenkins is an educator who is deeply concerned with the need for greater creativity in today's children. To this end, she designed "Sense Adventures" and "Imagination Adventures," classes for young children using art activities to develop their sensory awareness and expand their imaginations. She has also taught many teacher and parent education classes to help further promote children's creativity. Dr. Jenkins holds a Ph.D. in Education and has written *The Magic of Puppetry* (Prentice-Hall). She lives in Bellevue, Washington, with her husband and two children.

PART ONE

ART PRINCIPLES

Since every child is born with the power to create, that power should be released early and developed wisely. It may become the key to joy and wisdom, and possibly to self-realization. Whether or not the child becomes an artist is immaterial. (4)

FLORENCE CANE

PART ONE
ART PRINCIPLES

introduction

THIS is intended to be a two-books-in-one resource guide to

- Help teachers and parents understand the great value of expressive art for the young child.
- Offer suggestions for establishing a creative climate based on an awareness of the creative process and creative child.
- Suggest methods of teaching, motivating, and evaluating in keeping with the philosophy of art education presented.
- Offer an organized variety of specific experiences to help children grow in art.
- Direct the interested reader to sources for further study.

The book is directed toward those involved with children in the 3 through 8 age group, although there is no upper age limit for the use of most of these materials. The reader will gain a good foundation in the philosophy of art as it pertains to the child of this age group and will be able to share more understandingly the child's joy in artistic expression.

The book has been prepared almost as two-books-in-one, both halves being able to stand alone. There are separate tables of contents, and the bibliography is split into two parts. However, the real strength of the book comes from applying the principles of Part I to the practices of Part II.

Part I, Art Principles, presents the philosophical foundation without which the practice of art loses many of the values for which the art experience is intended. Although art can be an end in itself, I propose it as a means to an end, and many important goals are mentioned in Chapter 3, Value of Art to the Child. A most vital one is the development of creative thinking in youngsters. The creative person is sorely needed in today's society. We must encourage attitudes and abilities that will help children meet future challenges creatively.

For this reason, and because it is so essential to the philosophy of the book, I suggest that Chapter 8, *The Creative Climate,* be given very special attention. None of the rest of the book would be very effective if a creative climate, internal and external, were not initially established.

It is hoped that the reader will see Part I as the real foundation of the book and study it thoroughly before undertaking the specific activities outlined in Part II. To attempt these activities in a noncreative climate would be against the whole spirit of the book.

Part II, *Art Practices,* provides a reference to quantities of materials usable with young children and ideas on how to use them. It offers all the basic art media and more than enough of the novel for any art program.

It should be stated that the adult does not need to demonstrate capacity as an artist or even know how to draw in order to guide children in art. In fact, the more "artistic" teacher is too likely to influence the children with adult techniques and ideas. The teacher or parent needs to assume leadership in bringing out the creativity within the child, not imposing one's own ideas.

The most important things a child learns in school (or anywhere) are ideas about him- or herself. So often these ideas form into a self-concept of "I can't," "Why try?" "I'm not capable," "I'm not worthwhile," "What's the use?" Art, for such children, could be the one bright light in the curriculum—the time of day or week when they *can,* when they *are capable,* because an accepting

adult celebrates each one's efforts. Such appreciation from a significant adult can cause the child to start thinking highly of him- or herself, which might never occur if only academic subjects are offered during the school day.

Mark Twain said, "What a man thinks of himself, that it is which determines, or rather indicates his fate." What an opportunity we have in the field of art to help our children think highly of themselves and develop their own special uniqueness.

Anyone planning to teach art,
no matter at what level,
ought to know what art is,
or what experts believe it is. (8)
E. B. FELDMAN

1
what is art?

ART as used in this book refers to visual expression or visual state-
ment. Following are some significant statements that help to illumi-
nate this elusive word:

Art is a language that crosses time, space, and cultures.
SUSAN GARRETT

Art is the signature of civilization.
BEVERLY SILLS

Art is to society as dreams are to a person.
LALIBERTE AND KEHL

Art is the creation of forms symbolic of human feeling.
SUSANNE K. LANGER

Art is a process of rendering concepts into human form.
HELEN MERRITT

*Art refers to the conscious efforts of human beings
to arrange colors, shapes, lines, sounds, movements
and other sensory phenomena, to express their ideas
and feelings about themselves and their world.*

COHEN AND GAINES

*Art, to the child, is more than a matter
of painting pictures or making objects.
It is a means by which he expresses his individuality
and communicates his ideas about himself and his world.*

JANE COOPER BLAND

*Art is a way of finding out what the world
is really like, insofar as it causes us to view things
more objectively and also more subjectively.*

JOHN B. MITCHELL

*Art is the most natural means
by which man expresses his creativity.*

RITSON AND SMITH

*Art is an extension of the person,
an expression of who I am and what I am.*

SABO AND HARRISON

Art a private feeling made into a public form.

JUDITH ARON RUBIN

*The source of art is not visual reality,
but the dreams, hopes and aspirations
which lie deep in every human.*

ARTHUR ZAIDENBERG

*Art is an intellectual and emotional recording
of an attitude or an experience
presented in a personal manner.*

JAMES A. SCHINNELER

Art is simply a question of doing things, anything, well. . . .
When the artist is alive in any person,
whatever his kind of work may be,
he becomes an inventive, searching, daring, self-expressive creature. . . .
He finds gain in the work itself,
not outside of it.
ROBERT HENRI

Art education seeks to develop
sensitive, creative and artistically literate individuals
who may grow aesthetically, emotionally and intellectually
through active expression or reflective appreciation in the arts. (15)
IRVING KAUFMAN

philosophy
of art education

WITH the descriptions of art as presented in Chapter 1 in mind, the purpose or philosophy of art education can be more readily understood. The important aspects of art education are the creative process, the self-expression, and aesthetic awareness, certainly not the finished product.

The list on page 11, inspired by Lowenfeld and Brittain (21), will help to clarify any confusion between the philosophy of art education and the philosophy of fine arts.

Putting it another way, Harrison (9) asks us to distinguish between "education in art" and "education through art." The first teaches art, the second fosters self-expression. The one is for formal training, and the other for the emerging of the unique personality.

Frank Wachowiak (32) separates visual statements from art, saying that such statements relate more to elementary writing, and art is more akin to poetry. For the young child, elementary writing seems preferable to me. Poetry will come later.

In the preschool years and later, the guiding adult should be concerned only with what is happening within the child—the

PHILOSOPHY OF ART EDUCATION	PHILOSOPHY OF FINE ARTS
• Emphasis is on encouraging creativity regardless of where it is used.	• Emphasis is on the aesthetic value of the end product.
• The creative *process* is most important.	• The final *product* is most important.
• Art is used as language.	• Art is used as art form.
• Emphasis is on sensitive viewing, visual literacy.	• Emphasis is on doing, making.
• Feelings behind the work are most important.	• Aesthetic appearance is most important.
• Encourages experimentation with materials.	• Encourages training and techniques.

growth that is taking place and the child's feelings about him- or herself. Too much concern with the finished product can be detrimental at this stage.

In summary, a good art education program is one that helps children to grow creatively, aesthetically, socially, emotionally, physically, and intellectually.

The basis of this philosophy of art education will be apparent from the following chapter on the Value of Art to the Child.

It is only when one can justify
the teaching of art in a realistic,
humanitarian way, that one is ready
to start teaching art. (28)
RITSON AND SMITH

3

value of art
to the child

WHY is art so important? Has it really any worthwhile value to the child? Following are ways in which art is of value to the young child. These can also be considered as the goals of an art experience, and projects can be evaluated according to them.

1. Develops creative thinking
2. Provides means of communication and self-expression
3. Serves as an emotional release
4. Strengthens the self-concept and confidence
5. Increases self-understanding
6. Heightens aesthetic awareness and sensitivity
7. Enhances the ability to visualize
8. Provides problem-solving/decision-making opportunities
9. Develops appreciation for the individuality of others
10. Leads to the integration of the individual
11. Serves as a balance to classroom activities

12. Aids physical coordination
13. Develops work habits and a sense of responsibility
14. Aids the adult in understanding and helping the child
15. Generates joy

In the following pages these values of art are discussed.

1. ART DEVELOPS
CREATIVE THINKING.

It has been said that the best preparation for creating is creating itself. Since creativeness in all fields has common attributes, promoting creativeness in one promotes creativeness in general. For instance, if the child is allowed to experiment in art, he or she is more likely to do so later in the science laboratory. Thus, the foundation is laid for future contributions to society.

Creativity is defined as the process of recombining known elements and past experiences to produce something that is new to the individual—either ideas or products. Mixing blue and yellow paint for the first time can be creative if the child was not previously aware of the resultant green. At the highest level of creativity, the results can be something new for the world, and this is what we hope for. Never has there been more need for a creative approach to the problems in the home, the community, the nation, and the world than there is today. Our best hope of dealing with the dangers

of the nuclear age lies in the immense potentiality of creative ideas. Whatever, then, promotes creativity is of inestimable value.

James A. Smith (31) reminds us that "creativity can be developed through art, but only if the concept of creativity is kept perpetually in mind. Teaching some kinds of 'art' can destroy creativity." He says, "Art offers the most accessible avenue to creative development in the elementary school program at this time."

To promote creativity, the experience in art must be open-ended. That is, the problems presented should be solvable in various ways. This helps to produce divergent thinking—the thinking that produces many novel and different answers. Research indicates that this kind of thinking is the most promising for the development of creativity, as opposed to convergent thinking, where thoughts focus on a single "right answer."

Most education today is devoted to convergent thinking in the form of fact gathering. But facts are useless unless and until something is done with them. And divergent thinking is the means to make the widest and best use of the facts. An analogy to the kaleidoscope is fitting. The facts are represented by all the little pieces in the kaleidoscope, and the turning and twisting of the drum to produce new patterns is the divergent-thinking process.

In essence, creative thinking is an attitude that can carry over into all areas of a child's life to enrich his or her world and ours.

2. ART PROVIDES A MEANS OF COMMUNICATION AND SELF-EXPRESSION.

Art is language first, and only incidentally an art form, according to Jameson (11). Verbal expression is inadequate for many people. Words can inhibit as well as aid natural expression. Young children find it especially difficult to put their ideas and feelings into words.

Art offers them a way of making statements about themselves and their world that cannot be made by other forms of expression. Children's verbal ability may be limited, but they can express sophisticated concepts and complex ideas through drawing or painting. Drawing requires them to be more exact in their communication, whereas verbal descriptions can be, and often are, vague.

Expression or communication is also an important part of the learning process, for nothing is truly learned until it is externalized in some way. Hence, children's experiences are not complete until they can *ex*press their *im*pressions. Art is an effective way of doing this. Also, it should be noted that inhibitions result when there are not enough avenues open for expression. Health and happiness require adequate outlets for self-expression.

3. ART CAN SERVE AS AN EMOTIONAL RELEASE.

The therapeutic effect of art has long been recognized. Feldman (8) says that artistic creativity constitutes a socially acceptable and personally rewarding outlet for the accumulation of pent-up energies that everyday life contributes. At the same time the child is creating something satisfying, he or she is solving problems of tension or frustration.

Art is a great safety valve to drain off tensions and feelings that might otherwise pile up and become destructive to oneself and others. Children who have found they can turn feelings into creative channels have an outlet that will help safeguard them all their lives, protecting them from the emotional overload that many adults carry.

To quote Mendelowitz (23), "The habit of using artistic expression as an emotional cathartic, a way of relieving tensions and resolving difficulties, if established in early childhood, can contribute greatly toward an emotionally relaxed and healthy personality." He says that painting is a form of "playing it out." "Playing it out" is the natural self-healing measure of which Erik Erikson speaks in *Childhood and Society.*

4. ART STRENGTHENS THE SELF-CONCEPT AND CONFIDENCE.

"Self-trust is the first secret of success," said Ralph Waldo Emerson, and the art arena is a place to build this self-trust and confidence. Self-confidence is a feeling of assurance in one's own judg-

ment, ability, and power. When children find their artwork accepted and respected for its own quality, and there is freedom from pressure to conform or compete, their self-confidence is strengthened. They gain confidence, too, through the many decisions, challenges, and problems that are met in the course of creating.

Appreciating the child's artwork boosts confidence.

By encouraging in children this ability to think for themselves, in their own unique way, a healthy self-concept is fostered. It is often the only time when the adult is saying, "Do it your way—not my way," or "You are special and worthy." Evidence of growth in confidence is shown as the child expresses ideas and feelings without falling back on stereotypes.

The child with self-doubts is vulnerable to "put downs"—disparagement. Art can be the vehicle for building his self-worth, since it is in art activity that the child's uniqueness and inherent worthiness are especially recognized. This bolstered self-esteem spills over into all areas of a youngster's life.

The self-concepts of children in the "scribbler" age are boosted when they discover that they can create a new entity, can alter the world by making marks on paper or clay. A feeling of confidence and power is gained, too, by making something out of nothing. When artwork is appreciated by another, the child's individuality is recognized in a more personal way than by a compliment on reading or math.

A moving story is shared by Jameson (12) about a class of some 20 slow learners, supervised by a qualified art teacher. The academic class next door began sincerely praising the "smashing" paintings they saw on the walls. This so spurred the children that their room soon became a center of visual interest for the whole school. The new feeling of confidence the children gained carried over into their other activities. Some jumped over two years in reading.

5. ART INCREASES
SELF-UNDERSTANDING.

Art serves as an instrument of self-discovery. Allowed the freedom of choices, children gain much self-knowledge through art. They discover their own points of view. Their choice of subject matter, materials, and colors will be revealing. They learn whether they work better in groups or alone, and whether their own resources are sufficient or they need suggestions from others. Cohen and Gainer (6) say, "Art enables children to make tangible contacts with their own ideas and so better understand themselves." Seeing

others' ideas and approaches, different from their own, can add to this self-knowledge.

6. ART HEIGHTENS AESTHETIC AWARENESS AND SENSITIVITY.

Experiences in art sharpen all the senses. Visual power is increased—the power to see more, to be more visually literate. As children become more sensitive to the things they draw and the materials they use, their senses are sharpened and they become more aesthetically sensitive to their environment. This visual awareness can carry over into an awareness of clothing, home furnishings, architecture, city planning, in fact, the whole world. This makes the artistically trained person a better judge of the environmental needs in the world around him or her. (Such a person is even considered a superior witness at the scene of an accident.)

Most children will not grow up to be creators of art, but they can become intelligent consumers and perceptive interpreters in their world.

7. ART ENHANCES THE ABILITY TO VISUALIZE.

Visualization, the ability to see a mental picture of something that is not there, is vital to art and to creativity in general. Young children begin life relating visually to their environment, but this image-making ability is sometimes conditioned out. Their skill in art depends on the development of mental imagery.

This ability to "see it in your head" is vital to becoming a good thinker, to being able to foresee the results of one's actions, to achieving whatever one wishes to accomplish. For instance, by visualizing each proposed solution to a problem and how it would work out in practice, many disappointments can be prevented. A mass of evidence now shows that original thinkers in math and the natural sciences use visual thinking more than verbal thinking. It is an ability that can be strengthened through art.

Vivid imagery is correlated with seeing the world accurately.

Art enhances the ability to visualize.

We never see the shape of anything—a shell, a dish, a rock, a pet, more clearly than when we are drawing it. Vivid imagery needs to be encouraged by parents and teachers to offset the emphasis on verbal thinking that is found in the traditional educational curriculum.

8. ART PROVIDES
PROBLEM-SOLVING/
DECISION-MAKING OPPORTUNITIES.

Both children and adults are required to make countless decisions as they arrange, paste, paint, draw, or model. They must first decide such things as subject matter, materials, and tools, and then shape, size, color, value, texture, and pattern. An evaluation process is going on from the moment the creative work is undertaken. And

only the artist can fairly evaluate the work because only he or she knows the purpose.

Florence Cane (4) reminds us that most of the problems the student meets in his or her artwork have their parallel in life, and by facing them and solving them in art, the child grows as a human being.

9. ART DEVELOPS AN APPRECIATION FOR THE INDIVIDUALITY OF OTHERS.

By seeing the work of others, the child learns to appreciate different ideas and to understand that often there is more than one right way to do a thing. Parents and teachers can foster this understanding by appreciating each work for its uniqueness.

Art develops an appreciation of others' individuality.

10. ART LEADS TO INTEGRATION OF THE INDIVIDUAL.

A feeling of unity is felt when creating a work of art because the creative process integrates all one's experiences—thinking, feeling, perceiving—and relates them to one another.

The process of integration is the process of becoming a balanced individual. We understand the world through three chief functions—movement, thought, and feeling, says Florence Cane (4). Usually one of these three lies dormant, neglected, but art, she states, can be the key to activating the unused function. A well-balanced use of these three forms of activity leads to an integrated personality.

A newer way of understanding this unifying effect of art is explained by the field of research that is investigating the functions of the two hemispheres of the brain. "Split brain" research shows each hemisphere complete in itself and specializing in different functions. Schools primarily teach the "left brain," which is associated with the verbal, temporal, logical, analytical, rational, and sequential. The "right brain" appears to be the creative part and is associated with visual-spatial thinking, intuition, the abstract, nonverbal, and tactile. This half of the brain is virtually neglected in students.

We need to put more emphasis on "right brain" teaching if we wish to develop creative thinking, and this can be most easily done through the arts. Much research is showing that when both brain hemispheres work together, such as in the formation of a work of art, a physiological harmony occurs and a psychological sense of wholeness is achieved. The habit of using just one side of the brain narrows one's personality. Drawing is an effective way of gaining access to and control over the function of the right hemisphere says author Dr. Edwards (6c). She explains how "learning to see through drawing" may help children to later become adults who will put the whole brain to use.

11. ART SERVES AS A BALANCE TO CLASSROOM ACTIVITIES.

All genuine learning consists of both taking in and giving out. As said earlier, nothing is truly learned until it is externalized in some way. This can take a great many forms besides the visual arts—dramatic play, puppetry, dancing, writing, speaking, to name a few. Children need as much output time as input time. Yet, as they go along in school, the input time progressively increases, due to the volume of subject matter that teachers and parents feel must be poured in.

This is the overemphasis on "left brain" teaching referred to earlier. If the school is allowing half the brain to lie fallow, it is imperative that the guiding adult in the child's life provide output time. Creative art activities exercise the "right brain" and are a beautiful way to externalize what is being learned. Thus art can be the perfect instrument for teaching the "whole" child. It is the antidote the home can use to counterbalance the left brain activity of the school day.

12. ART AIDS PHYSICAL COORDINATION.

Both large and small muscle coordination is developed when the conditions for drawing and painting give free rein and space to total bodily movement. Through art activities, children increase motor control and eye, hand, and mind coordination. Free drawing, as opposed to coloring within lines, has been found to require and develop the skills needed for lettering and cursive writing. Physical coordination can lead to being less accident prone and more capable in other fields of endeavor.

13. ART DEVELOPS WORK HABITS AND A SENSE OF RESPONSIBILITY.

Art can be a means of learning and developing good work habits and the responsibility that accompanies the use of equipment and materials. Ritzon and Smith (28) explain that it is a way of achieving

Art can develop good work habits.

the essential elements of self-discipline and self-motivation. Handling one's tools becomes an extension of handling oneself—both requiring efficient work habits.

14. ART AIDS THE ADULT IN UNDERSTANDING AND HELPING THE CHILD.

Children's pictures are representations of what they have experienced visually, physically, and emotionally in their few years. Their art activities provide a key for understanding their concepts and ideas. They give aware adults a valuable insight into the areas of concern that children may repress in verbal communication.

A collection of a child's artwork can provide a useful record of growth. The degree of coordination in the artwork is believed to be an indicator of the child's readiness for reading and writing. Current studies show that art serves as an important bridge from speech to print. In one study children were helped to learn to

write by first expressing their thoughts in simple drawings. Adding descriptive sentences to explain what they had drawn was then the bridge into writing.

15. ART GENERATES JOY.

Joy is inherent in our nature, and there are certain sets of conditions that release it and allow it to bubble forth. Art experiences, when nondirected, usually meet these conditions. Real joy is a natural high, and such highs are associated with right brain activity, of which art is a prime example.

There is joy in expressing one's uniqueness or individuality and in being self-directed, which valid art experiences allow. Art offers the deep satisfaction of discovery—both of oneself and of what various materials can do. Then there is the pleasant sensation that comes from manipulation of the materials.

Much joy comes from an awareness and aliveness to beauty, in everyday objects as well as in art forms. Also, joy comes from releasing pent-up emotions in a constructive manner.

And what joy and delight can accompany creating something that never existed before! This can offer real meaning to existence.

There are other values to be found in art, such as the many cognitive skills, but the 15 we have discussed here are probably those of most importance for the young child. Certainly art is of value for its own sake, since it satisfies a basic need.

Although men are accus'd
for not knowing their
own weakness,
Yet perhaps as few know
their own strength.

It is in men as in soils,
where sometimes there is a
vein of gold, which the
owner knows not of.
JONATHAN SWIFT

Art is a beautiful way of exposing that vein of gold within the child. When expressive art is encouraged, through a variety of media, the child discovers abilities he knew not of. And isn't that what education is all about? Going within and drawing out.

4

methods used in teaching art

THERE are six easily distinguishable methods of teaching art. Blanche Jefferson's classic work, *Teaching Art to Children* (14), lists the six as follows with an explanation that only the first two promote creative expression.

Creative expression It is based on the child's choices and is identifiable because the content of each child's painting is different from the others.

The child chooses: 1) the topic for the art work 2) the way it will be expressed 3) the organization of it.

Assigned topics A general topic is given such as "snow" or "fun at the beach." The child can express and organize the topic in his or her own way.

Copy Copy experiences consist of reproducing the likeness of a model, picture, or design.

Directed methods The child follows a prescribed course set by the adult and controlled by the adult in a step-by-step procedure.

Patterns Patterns are shapes drawn or cut by another person which the child is to duplicate or assemble, as directed.

Prepared outlines The child colors inside the lines that someone else drew, as with coloring books or workbooks.

The first two methods of teaching art will help the child obtain the values already discussed—creative thinking, self-expression, emotional release, self-confidence, and so on. The last four methods—copy, directed methods, patterns, and prepared outlines—are considered "dictated art," that is, the end product is predetermined by the adult.

THE EFFECT OF DICTATED ART ON THE CHILD

How does "dictated art" (coloring books are the most prevalent form) affect the child?

- It causes loss of creativeness as there is no stimulation of the imagination. Research experiments have shown that a great many of the children who use coloring books lose their creativeness and sensitivity (13).
- It has a detrimental effect upon the children's self-confidence and independent thinking. They feel their own ideas are unacceptable, and they become conformists by changing their concepts to resemble the stereotype.
- It deprives children of individual expression since they cannot express their own relationship to the subject. For instance, if the subject to color is a dog, they cannot express their own feeling about dogs.
- It provides no emotional release because it gives the children no opportunity to express their own experience, and thus relieve tension—joy, hate, fear, and so on (22).
- It does not promote skills and discipline because children's urge for perfection grows out of their own desire for expression. Ex-

perimentation has shown that there is more incentive to "stay within the lines" if the child has drawn the picture him- or herself (21).

- It is frustrating to the child's own creative attempts because it conditions the child to adult concepts he cannot produce alone. Mental and emotional confusion is caused (14).
- It encourages inflexibility and rigidity because the child has to follow what he or she has been given.
- It offers the child no feeling of achievement or pride in his or her work, and the child feels the falseness of the praise offered (13). See Chapter 7 regarding the misuse of praise.
- It promotes doing without thinking. This can cause unthinking obedience to an authority, which is better training for totalitarianism than for democracy (13).
- It does not provide practice in the decision making required in democratic living. No choices are allowed except for color, and more recent books even tell the child what colors to use.

"Dictated art is not art but a contradiction of it, for every art form must be conceived and executed by the person undertaking it" (13).

In spite of the fact that coloring books are "dictated art," some parents have found ways to use them while still promoting creative thinking. These ideas are applicable for about third grade and up. Such activities could include

- Changing the characters so that they look like they came from outer space.
- Making the characters look angry, sad, and so on.
- Adding comic book balloons to the page and putting in words for the characters.
- Animating objects by adding faces.
- Drawing more things on the page or adding magazine pictures to make a different statement.

In teaching art to young children, it is important to find the balance between directing them and just letting them do as they please. Telling them to do anything they like is often not successful because few children are self-motivated at this age.

It is important to avoid projects where the adult does very much directing. No matter how attractive the end product, the child concludes that the work is really not his or her own and is robbed of the opportunity to think creatively. Be assured that you are saying and doing too much if the art projects of the children all come out looking very similar.

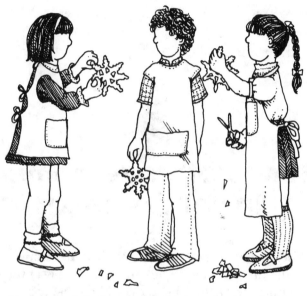

Too much adult direction results in art projects looking very similar.

If teaching for creativity is kept uppermost in mind, one cannot go wrong in art teaching methods. The other values, such as self-expression, confidence, understanding, visualization, integration, and such, would all automatically be taken care of. Teaching for creativity so completely values the individual that no two products can look alike.

An integral part of teaching methods is the motivation used to introduce the project. Many suggestions for initiating art experiences that encourage creativity can be found in Chapter 6, on Motivation. Refer also to Chapter 7 on Evaluation. It is closely associated with teaching methods, since evaluation takes place throughout the art activities.

stages of development
in children's art

WHAT children paint is determined by their developmental level, their particular interests and experiences, and the way they perceive things. The purpose of this chapter is to help parents and teachers become more aware of the developmental stages in the art of young children. Children will pass through these stages at their own rate, so it is important to remember that the ages specified here are only approximate. For instance, whatever their age, most people go through the stage of manipulation when presented with a new material. The following stages are taken from the *Elementary Art Guide* (3) for the State of Washington:

 I. MANIPULATIVE STAGE The approximate age of this stage is 2 to 4 years, but for children who have not had much opportunity to manipulate materials, it may be in kindergarten or even later.

 A. Random Manipulation
 Art characteristics usually evident in the child are

- Uses all his senses to discover the unique qualities of the material
- Makes random marks on paper in efforts to gain control of the tool
- Drips paint and overpaints
- Squeezes, pokes, pounds, and punches clay, etc.
- Attempts to pile blocks
- Is not trying to draw, model or build objects; the experience is purely kinesthetic

B. Controlled Manipulation

As the child gains control over his materials, he develops muscular coordination to the point where he can repeat certain motions at will. Art characteristics usually evident are

- Can push the crayon back and forth over the paper, making bold, dark lines.
- Can push the crayon around and around
- Piles blocks and hammers pegs into holes
- Pulls, rolls, and squeezes clay and play dough
- Starts to name his scribblings; indicates a change from kinesthetic thinking in terms of motions to imaginative thinking in terms of pictures

Children pass through the stages of art at their own rate.

- Accidental forms may change their identity several times before completion

II. SYMBOLIC STAGE

A. Early Symbolic Stage

Approximate age, 4 to 7 years. In this stage a child will usually control his movements and create symbols for certain ideas and feelings he wishes to express. At first, these symbols may not be recognized by the adult.

Characteristics usually evident in the product are
- Ideas are expressed by symbolic lines and shapes
- Shapes become more controlled and as the child advances he can produce shapes at will
- Detail is developing gradually
- Usually only parts important to the expression are used (if legs are not important they may not appear)
- There is usually no relationship of color to object
- Color is used emotionally

B. Later Symbolic Stage
Approximate age 5 to 9 years. As a child develops, he uses art media to communicate his ideas and feelings. Characteristics evidenced by the child
- Expresses what he knows, not what he sees
- Divides paper into ground, air, and sky
- Exaggerates the things that are important to him
- Has discovered the relationship between color and objects
- May show episodes occuring at different times in the same picture

When learning to speak, children practice making many kinds of sounds. It is the same when they are learning to make symbols that represent ideas or feelings. They must practice making many kinds of marks. Often, this practice includes a period of repetition of forms. This repetitive time fulfills a need and should be respected. It is comparable to the child wanting only the exact words of a favorite story or a daily routine, without any change in the order of events. Through repetition, the child gains the sureness of achievement that builds confidence.

Rhoda Kellogg (16), who has an enormous collection of children's art from all over the world, has discovered that young children everywhere draw the same things, in much the same way, at the same age. She has found that there are 20 basic scribbles that are the building blocks of art. Children 2 years old and even younger make these marks, which are placed in a definite relationship to the edge of the paper. By the age of 3, she says, children can make diagrams, of which there are eight basic shapes.

Two diagrams are eventually put together to form a combine. Kellogg found 66 combines possible if diagrams are looked at in three ways—separately, overlapping, and containing.

From combines, children go to aggregates, which are units of three or more diagrams. The number of possible aggregates is infinite, and they constitute the bulk of child art between the ages of 3 and 5, Kellogg discovered.

Examples of the 20 basic scribbles and how they evolve from diagrams to aggregates to the human figure are shown in Figures 1 and 2. They are from *Analyzing Children's Art* by Rhoda Kellogg (16).

According to Rhoda Kellogg, not all these steps may appear in the work of every child, but they apply well to large quantities of work by many children. Similar steps take place in the evolution of other subjects.

The reader wanting more on the developmental stages of children's art is referred to Chapter 3 in the Ritson and Smith book (28), to the Lowenfeld and Brittain classic (21), and to the section on drawing in Piaget's work *The Psychology of the Child* (56a).

FIGURE 1. THE BASIC SCRIBBLES

Scribble 1		Dot
Scribble 2		Single vertical line
Scribble 3		Single horizontal line
Scribble 4		Single diagonal line
Scribble 5		Single curved line
Scribble 6		Multiple vertical line
Scribble 7		Multiple horizontal line
Scribble 8		Multiple diagonal line
Scribble 9		Multiple curved line
Scribble 10		Roving open line
Scribble 11		Roving enclosing line
Scribble 12		Zigzag or waving line
Scribble 13		Single loop line
Scribble 14		Multiple loop line
Scribble 15		Spiral line
Scribble 16		Multiple-line overlaid circle
Scribble 17		Multiple-line circumference circle
Scribble 18		Circular line spread out
Scribble 19		Single crossed circle
Scribble 20		Imperfect circle

FIGURE 2. EVOLUTION OF PICTURES OF HUMANS FROM SCRIBBLING

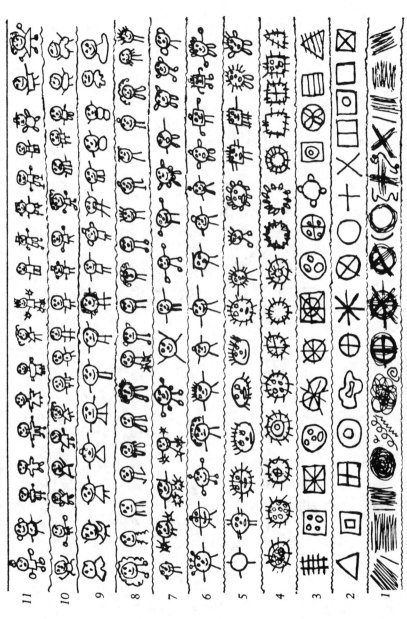

Going from bottom to top, these Gestalts represent the probable evolution of Humans from earlier scribbling. The Basic Scribbles at the bottom lead to (2) Diagrams and Combines; (3) Aggregates; (4) Suns; (5) Sun faces and figures; (6) Humans with head-top markings and with arms attached to the head; (7) Humans without head-top markings; (8) armless Humans; (9) Humans with varied torsos; (10) Humans with arms attached to the torso; and (11) relatively complete Human images (author's sketches)

Creative thinking precedes creative working. (13)
BLANCHE JEFFERSON

6

motivation and guidance

MOTIVATION is not something we do to other people. It is something they do to themselves. We can only give them the reasons or stimulus for motivating themselves. Art motivation means to stimulate thinking, feeling, and perceiving in such a way that there is a desire to communicate ideas visually. Guidance takes place during the creative process as problems arise and is offered on an individual basis.

The purpose of this chapter is to offer some workable ideas for motivating and guiding children and to suggest good sources that the interested reader can turn to for more depth.

MOTIVATING THE YOUNG CHILD

Although this book is specifically intended for preschool teachers and parents without an art education background, primary teachers will find much in it for their use. However, keep in mind that

much that is said in this chapter and the next is not equally applicable to all children in this 3-to-8-year age range. Different motivations are needed depending on the stage of the child's development, and children of the same age can certainly be at different developmental stages. It is best to read for general ideas or an overall feeling.

Some authorities feel that "every artist of every age needs to be inspired before he creates" (14). Because creating is such a demanding task, the artist needs to be strongly motivated to begin it and then to carry it through. The function of the adult is to stir up the feelings of every child until each is eager to get to work. As Blanche Jefferson reminds us, "emotion causes motion," or to put it another way, feelings create action. The stronger the emotion, the more the art expression will come from deep within the child.

Florence Cane (4) says, "If you touch real feeling in a pupil, you generate energy without measure. Therefore, it is important that the subject matter of a pupil's work mean something to him, his whole self—not just his thinking mind, but his whole being."

Creative thinking does precede creative working, but we must keep in mind that the preschooler who is at a scribbling stage has no creative intention other than exploring the material and

what it can do. Enjoyment comes from the kinesthetic sensation and its mastery. For most preschool youngsters, motivation should be inconspicuous and gentle. They are sufficiently "turned on" by attractive art materials, a comfortable place to use them, and a bit of encouragement. If they have stimulating surroundings and plenty of firsthand sensory experiences, they usually have all the motivation they need. Where this is not sufficient, additional motivation should be provided.

School-age children seem to require more motivation. Unless properly stimulated, they may tend to make generalized pictures, which are not personally expressive and are really "warmed over" ideas used in the past. It is easy to fall back on such generalizations and "warmed-over" ideas when one's thinking has not been challenged. This is where help from the adult is needed.

Motivation is usually derived from one of two sources—current material on hand or one's past experience (bringing the past into the "now.") Under each of these two categories, specific motivational activities will be presented, but first some general comments are in order.

Attitude Reminders

Before effective motivation can take place, an attitude "set" must be established.

Let the children know that:

- They are unique and special.
- Nobody else can do and say things their way.
- No one else in the world has experienced things exactly in the way they have.
- Something is always happening to them or within them that others really want to hear about.
- Art is a safe and wonderful way to express their own special experiences, perceptions, and feelings.
- There is nothing they cannot do if they want to enough.
- There is no one right way to do things in art.

It is not enough just to say these things. The adult must really see the children as worthwhile human beings loaded with untapped potential.

Snowflake idea To get children into the "mind set" that they are unique and special—that, therefore, their art cannot be expected to look like anyone else's—one teacher uses the snowflake idea. The children are each given a piece of typing paper or white paper napkin and instructed to close their eyes and simply follow directions. The teacher tells them to fold the paper in half, tear a half-circle out of an edge, tear a corner off, fold in half again, tear another half-circle out, tear off another corner (the instructions vary depending on the ages of the children). Then with eyes open, they open up and look at their papers and take a look around at each of the others. They will probably express surprise at how different each one is. The adult explains that even though they were all given the same instructions, their interpretations varied because they are unique individuals. The same kind of individualness is expected in their art, even if all are drawing the same object. This theme can be carried on through to evaluation time, making it fun to look for the differences in the art products.

Self-worth Remember that whatever builds a child's self-esteem (the feeling of self-worth) will lead to an improvement of skills. Charles Schaefer (60) says it this way, ". . . as a child develops pride in his own thoughts and in the desire to communicate them to others, he will be motivated to improve his skills of execution." Some teachers have seen great improvement in youngsters' behavior and work just through building their self-esteem. As young people are able to feel, think, and say "I like myself," all areas of their lives start to improve.

A motivating climate Some art teachers help to create the motivating climate they want through the use of attractive signs and posters in the room. One leading teacher has a prominent banner stating "Why Copy When You Can Create?" This theme becomes well impressed and often carries over into other areas of the child's life.

Other teachers have put up positive declarations as "seed thoughts." Examples are: "I enjoy art," "I am a creative person," "I am able to think of new ideas," "I enjoy expressing my ideas," "Art is not to be perfect," "I can do what I make up my mind to do," "I am a worthwhile and capable person," "I enjoy drawing in my own special way." Such thoughts help to off-balance some of the negative self-concept ideas that children carry around with them.

Your expectations Because of the power of expectations, it is important to remind the children continually that you value and expect imaginative responses. Encourage fantastic and "way out" ideas. Make it acceptable for them to let the imagination fly. Remember that one person's expectations can influence another's.

Once you have encouraged children to express their own feelings or to stretch their imaginations, do not become upset or feel threatened because they are not doing things the way you had predetermined that they should.

Praise or appreciation for the child's efforts is a big motivating factor (dealt with in more detail in Chapter 7). A hesitant or insecure child needs heaps of praise for his or her first attempts in order to continue trying. Be "appreciation minded." William James, a well-known American psychologist, said, "The desire to be appreciated is one of the deepest drives in human nature."

Other Reminders

Be clear in your own mind about the objectives of the art activity. The overall objective should be to have every child achieve a feeling of success—a good feeling about himself and his efforts. The secondary purpose should be the objective of the particular art experience, and this should also be kept well in mind. The more clear you are in your own mind, the more the children will catch the feeling. So much more is "caught than taught." Motivation begins in your own thinking.

If the planned art project does not fit the short attention span of young children, no matter how stimulating the motivation, you will lose them. Also, do not expect motivation to carry over to the next day with young children. Their memory is such that an

art activity will be much more successful if completed in one session.

But be aware also of when to stop the motivation. Going on too long past the time they are ready to create can cause you to lose them, just as the salesperson loses who does not close the sale when the customer is ready to buy. Stop at the high point of the motivation.

Remember that you do not need to know how to draw or sculpt to help children to do so. You help them by getting them to look and to feel (see Chapter 21).

If new materials or a new process is to be used in the project, include an explanation or demonstration of the procedure in your motivation.

Be expressive and enthusiastic yourself. The more eager, the more dramatic you act, the more they will catch the spirit. Be eager about the experiences they are about to have and excited about the results you expect.

CENTERING

At most any age level, centering can be a beneficial activity before getting into the actual art materials.

To feel centered is to feel a psychological balance, a sense of inner strength, a dropping of false identity (or masks).

The more the child can strip off the mask that many homes and classrooms foster and can "listen within" to the true self, the more self-motivated will be his or her art work. It is only through tapping the Source Within that the child can experience who he or she is, says Dorothy Briggs (37).

She offers a simple and effective centering activity consisting of three steps: stilling the body, stilling the mind, and knowing (via affirmations). The affirmations (positive self-statements) need to be adjusted to the child's maturity level.

Centering can take many forms, but in school it is usually a verbally guided exercise where the child is led to the quiet place within to get in touch with true feelings and his own unique ideas. Deep relaxation accompanied by deep breathing leads the child

to that pool of inner stillness, the source of fresh inspiration. Many believe there is a direct correlation between taking time to be centered and one's ability to express creatively.

"This withdrawal from the outer world, this shutting out of confusion and overcrowding from the mind, lets the pure thought or image shine through," says Florence Cane (4). To be centered is to have the intellect and the intuition work in harmony, explains Hendricks (50). The reader is referred to her two books for centering activities that can be done in conjunction with art or other school functions. She believes that knowing how to feel centered is as important to young people as knowing how to read, write, and brush their teeth.

Soothing music is used by some educators to aid the centering process or to maintain the quiet atmosphere that allows new ideas to bubble forth from deep inside.

Whether one chooses to call it centering, "listening within," or something else, it is beneficial to take a few minutes before beginning an art project and get the children to clear their heads of scattered cluttering thoughts. Where there are masks, there cannot be openness. Centering can dispel masks and help the child be more open with his art work. It can really allow the joy of art to bubble forth.

MOTIVATION
THROUGH MATERIALS ON HAND

In general, the younger the child the more motivated he or she is by material in the immediate environment.

Materials/Medium

Here the art material is the major factor in motivating the child. The child works with a new medium and discovers possibilities and ideas by experimentation. New materials can be motivating no matter what the age of the person, from 2 to 82.

Visual Stimulus

The idea is to intrigue, delight, or challenge the child by visual phenomena, as the following:

> Objects may be brought into the room that have unusual appeal—a crab, the insides of a TV, a skull, a live animal, a beautiful plant.

> Magnifying and minifying glasses can be used.

> Viewfinders are recommended by Jameson (12) (a piece of cardboard with a hole about 3 × 6 inches); the child chooses an area to view through it, indoors or out, and notes the lines, shapes, colors, textures, and any life.

Viewfinders can focus the
attention.

Films, slides, and pictures can be used to stimulate observation or arouse emotion. Teachers might wish to have a picture file that students can refer to when they want to know what an armadillo or an astronaut looks like.

Pictures can stimulate ideas and emotions and
aid the memory.

Music

Records, tapes, or instruments can stimulate visuals and emotions. To play the music immediately following the centering activity can be especially effective. Some teachers use meditation-type music to aid the centering process. Children are invited to let the music create a picture or design for them, and when they have an idea finally in mind, to open their eyes and go to work.

Poems and Stories

Poetry, like music, can be a powerful factor in freeing the imagination. When working with an individual child, let him or her stop your reading and go to work when words that "make a picture" come into the mind.

With stories, the adult can read up to a place of peak excitement and ask the child to create a picture of what might happen next. Or the child might draw a favorite part of a story after it is read. Older children enjoy interpreting, through art, fictional characters and events.

Excursions

Field trips to local points of interest—the zoo, bakery, harbor—with sketch pads in hand can be very stimulating. To draw or paint on the spot is especially rewarding or the artwork can be done at home or school, with the adult verbally refreshing the child's memory of what was seen.

"Looking and touching" walks would fit in here. They are exercises in directed observation where the adult helps children learn to explore with their eyes and hands. As Helen Merritt (24) points out, children do not necessarily see because they have eyes. They will not always spontaneously experience such things as the texture of a tree trunk, the smoothness of a stone, or the shape of leaves. They have to be carefully taught to see, she says, before they can have feeling responses to their visual environment.

MOTIVATION FROM PAST EXPERIENCE AND IMAGINATION

Of necessity, there is a lot of overlapping of these methods for stimulating a youngster's visual expression. Imagination activities are included as part of past experiences because they draw on stored material, impressions from the past.

Visualization Exercises/ Guided Imagery

This is a fun way to motivate an art experience and at the same time develop the valuable faculty of visualization. In the art world, visualization has always been considered indispensable, but more and more people are now becoming aware of how valuable a tool it is in any line of endeavor.

The parent or teacher can lead a guided imagery experience where, with eyes closed, the children see on their mental "movie screens" the objects or scenes described. The "word painting" of the adult should be vivid and graphic, so as to create powerful visual images. It can be as simple as the examining, cutting, and tasting of a lemon or it can involve a series of episodes at the

beach. The painting, drawing, or collage would be based on these images.

Many examples of imagination games for children can be found in the book by DeMille (42), *Put Your Mother on the Ceiling*, and *Scamper* by Eberle (44). A parent or teacher could easily modify them to trigger art expression.

Imaginary Worlds

Here the child is encouraged to draw or paint the people, animals, or plant life of an imaginary land. This could be initiated by a lively verbal discussion of all the possibilities, so as to stretch the imagination. Or a guided visualization exercise would be very appropriate, with the adult leading the child via spaceship to a new world and letting him or her fill in, with imagination, the people and animals met there.

What If/Just Suppose Questions

The adult challenges the children with such questions as "what if insects were larger than people?" or "cows were the size of cats?" or "the sun shone all night?" or "everything was shaped like a circle?" or "water ran uphill?" or "children were giants and parents were midgets?" and so on. Children need to be challenged to come up with a great variety of responses and also to make up their own "what ifs." The art expression can be their response to the idea that most intrigued them.

> *When the imagination is used, the work of art will*
> *express greater truth; it will place the emphasis*
> *on the spirit rather than semblance (4).*
> FLORENCE CANE

In essence, motivating others is more of an attitude than a technique. Author and lecturer Bob Conklin (40), says that motivating is a way of loving because it is helping people become what they are capable of becoming. He concurs with Ralph Waldo Emerson, who said, "Our chief want in life is somebody who shall make us do what we can."

"What if cows were the size of cats?"

GUIDANCE

Once the youngster is motivated and into creating, problems often arise that call for adult guidance. Through this guidance, Jefferson (14) points out, the adult leads the child toward

Definitions of his or her problem.

Consideration of possible solutions.

Information that aids in a solution.

Incentive to develop his or her art work to the extent of personal ability.

The child needs to be allowed to work independently, however, until reaching his or her own stopping point or sensing a problem. "When a child asks for help, guide his conceptual understanding, not his hand," is the way Coleen Menlove (98) expresses it.

The four W's are an effective way of stimulating youngsters' thinking so as to raise their level of achievement. The four W's—who, what, where, and when—are asked in such a way that the youngster becomes aware of what was left out or what more might be expressed. This applies to the older child who is used to art expression. Harrison (9) suggests that after the child tells about his or her picture, the adult can ask such questions as "Who else was there?" "When is it—day or night?" "What could you see around you?" "Where are you standing?" "What were you wearing?"—whatever is appropriate. Although she worked with 9–11 year olds, Natalie Cole (6b) has many creative instructions that could be useful with younger children, such as the following: "I wonder just how big this paper will let us paint?"; "Make your picture fill your paper till it bumps the sides"; "Things tucked in behind give interest to the picture."

Guidance is best offered individually, with the overall objective in mind of success for every child. As Jameson (12) so well states, "Every subtle device the teacher can invent should be used to cajole, persuade, flatter, goad, decoy, prompt, tempt, dare, provoke, encourage the child to work to the best of his ability." The important thing is to avoid the extremes of either rigidly directing the child's thinking or providing no direction at all.

For more details in this important area of motivation and guidance, the reader is referred to some excellent authors on the subject: Jefferson (14), Jameson (12), Linderman and Herberholz (19), Alkema (1), and Lowenfeld and Brittain (21).

Whether motivating or guiding, the following poem could be adapted to the childrens' maturity level and used as a reminder theme. For the very young, it could be changed to a simple story about a cowpath that earlier boys and girls followed through the woods when they went berry picking or to visit friends in town. Because it was so winding, it took a lot longer to get into town than if a straight path had been made, but no one thought about changing it. After a while the path was used by horses, and then

it was widened and used by cars. People got angry because the road was so full of zigzags and it took so long to go some place, but no one considered making a new road. Have fun embellishing the story to the delight and interest level of your children, but get across the point that you do not want them to follow calf paths. You want them to have the courage to create new paths that are all their own. Remind them—why copy when you can create? Also, let the poem remind you to avoid the well-established precedent when motivating children's art. Look for the more direct path to your goal.

Well-Established Precedent*

One day through the primeval wood
A calf walked home as good calves should;
But made a trail all bent askew,
A crooked trail as all calves do.

Since then three hundred years have fled,
And I infer the calf is dead.
But still he left behind his trail,
And thereby hangs my moral tale.
The trail was taken up next day
By a lone dog that passed that way;
And then a wise bellwether sheep
Pursued the trail o'er hill and glade
Through those old woods a path was made.

And many men wound in and out
And dodged and turned and bent about
And uttered words of righteous wrath
Because 'twas such a crooked path;
But still they followed—do not laugh—
The first migrations of that calf,
And through this winding wood-way stalked
Because he wobbled when he walked.

* Written in 1895 by Sam Walter Foss. (Has also been titled *Conformity* and *Calf Path.*)

This forest path became a lane
That bent and turned and turned again;
This crooked lane became a road,
Where many a poor horse with his load
Toiled on beneath the burning sun,
And traveled some three miles in one.
And thus a century and a half
They trod the footsteps of that calf.
The years passed on in swiftness fleet,
The road became a village street;
And thus, before men were aware,

A city's crowded thoroughfare.
And soon the central street was this
Of a renowned metropolis;
And men two centuries and a half
Trod in the footsteps of that calf.

Each day a hundred thousand rout
Followed this zigzag calf about
And o'er his crooked journey went
The traffic of a continent.

A hundred thousand men were led
By one calf near three centuries dead.
They followed still his crooked way,
And lost one hundred years a day;
For thus such reverence is lent
To well-established precedent.

The real test of whether a child's art is "good"
is not how much the tree he has drawn
represents the natural appearance of a tree,
but how fully the child, when working,
has entered into a personal reaction of his own
to the tree and its environment. (7)

ELLSWORTH AND ANDREWS

7

evaluation

TWO kinds of evaluation will be considered here: the adult's evaluation of the child's work and the child's evaluation of his or her own work—by far the more important type.

Evaluation should be concerned with the child's growth rather than with a perfected art project. Adult evaluation, according to Ritson and Smith (28), "requires knowing the child, how he perceives himself, his developmental stage, what he is trying to say, how he is feeling." With all this knowledge required to give a thoughtful evaluation, it is apparent why they say that to give an opinion requires all of "the careful thought that a surgeon might give to the question of an appendix removal."

PRAISE

Acceptance and respect for what the child creates are the basic rules. Probably the most common evaluation response is praise, which is fine, when not misused. Praise is so much recommended

in the literature that we are often misled into thinking that every-thing a child does deserves praise. This can be damaging, as "praise wrongly applied may nullify praise which is needed at a time when the child's self-confidence may depend on it" (21). If a child knows that he or she did not really try, praise can destroy confidence in you and cause the child to doubt your sincerity. Other dangers to watch for are: there can be pressure in praise; a child can become dependent upon this kind of reward; and if only some children in a group are praised, the effect can be most discouraging to the others. The child feels "Nothing was said about *my* work, it must be pretty crummy; I'm just no good at art." "Class, look at the

beautiful flowers Sue has made" can be interpreted by the others to mean that theirs are inadequate—they have failed.

When one does commend a child, it should be for what he or she has done and not for what he or she is. A person is not "great" for having made a great collage or drawing. We must be sure always to separate the child from the act and praise the act, not the actor. The child already is "okay." When children are hooked to their actions, they come to think that they are what they do. That can be most destructive to a healthy self-esteem and destruction of self-esteem contributes to the growing suicide rate among youngsters. (For more on self-esteem, see *Your Child's Self-Esteem* by Briggs (37) and *Building Self-Esteem* by Barksdale (35).

For further discussion of praise, see Ginnot (46) and Dinkmeyer and Dreikurs (43).)

Praise is most genuine and encouraging when the focus is on the child's efforts, not on the art product. Comments such as the following help keep the emphasis on the effort:

"You were really concentrating on that."

"I like the way you kept at that until it was finished."

"What made you think of that good idea?"

"Did you enjoy making that?"

"You seem to be having fun."

"What an interesting way to use the brush."

COMMENTS ON COMMENTS

When comments on the child's product are in order, remark on the original idea, the fresh new expression, the individual way of shaping a form. Even when at a loss, one can always say (with enthusiasm) "Nothing like this has ever been seen before," or "You are the only one who has done anything like this."

If one remembers how carefully comments should be made, "What is it?" questions will be avoided. Such queries are insensitive, and can destroy a child's self-confidence. Children may feel a sense of failure because their art is incomprehensible. They expect you to see it the way they see it. Also, asking a child about his or her painting indicates to the child that maybe he or she is supposed to draw something that can be talked about or at least named. Since nonrepresentational art does not lend itself to verbalizing, the child may abandon this popular art form in favor of something that can be named and discussed. By giving representational art the most attention, adults influence the child in that direction. If from the beginning you refer to the child's scribbles as "designs," you at least provide him or her with a ready answer for the inevitable "What is it" question.

Teachers are helping to educate parents in this regard when they send a "Dear Parent" letter home with the first batch of paint-

ings or drawings. The letter tells the parents how their reactions to the children's art can affect them for years to come. It warns against the indiscriminate use of praise and suggests questions that should be avoided and those that are acceptable. "What is it?" implies ridicule of the product and the child's efforts. "Tell me about it" can embarrass the child who does not yet have the vocabulary of words or ideas to describe his product. "How did you do this?" is truly acceptable, since the child's chief focus is on the process, not the product. It is the *doing* that satisfies him and he can happily tell you *how* it was done.

One school of thought holds that since art is a visual area, it should not require an explanation. It can stand on its own, not depending on another form of expression from the child. There should be opportunity, but not a demand, for the child to share thoughts and feelings about his or her work.

It is important not to read deep psychological meanings into a child's paintings and drawings. Art can be very revealing, but unless one has been well trained in art therapy and knows all the circumstances under which a painting was made, wrong judgments can be made. Also, since colors do not mean the same to young children as to adults, let's avoid using their color choices as indicators of their emotional state. We want to provide a safe climate where children can feel relaxed and accepted, while expressing themselves.

Depending on the age of the youngsters, parents and teachers who are familiar with the elements of art (line, color, texture, shape, value, form, space) and the language of color (hue, tint, shade) might consider using such terms in commenting on the children's work. Through a gradual process of communication, the child will become familiar with the vocabulary of art, as the adult points out the textures, comments on the balance of the shapes, or exclaims about the gracefulness of the lines.

BUILDING ON STRENGTHS

The child needs the feeling of success and creation that comes from the recognition of strengths and the overlooking of areas needing improvement. We might have trouble doing this in such

areas as math and spelling, but art is an easy place to build on strengths.

Jefferson (14) tells us that in the elementary school, it is sufficient to recognize and analyze achievements; secondary school is time enough to discuss the improvement of weaker areas. In that case, any criticism or comparison should be vigilantly avoided in the preschool years. Lowenfeld (21) says that "children's art does not need to please us in its external effects," that "criticism is based on adult taste, so does not fit the child's needs."

ART AS A REFLECTION

The young child's picture is more of a reflection of what he or she knows and feels than of what is seen. It symbolically reflects what is going on inside the child. Thus, the teacher should look at the drawing or painting as an index of the child's state and try to improve that rather than the product. It is the feelings and perceptions that need to be changed, not the marks and the colors. As Cane says, "If the child is fully alive, his work will be." How often in this world we tend to correct the effect and not the cause.

Keep in mind that what you are seeing is simply a stage in the process of the child's development. Therefore, your only evaluation should be of the progress the child is making from week to week. Consider where the child is now in relation to where he was at an earlier date. Look for evidence that learning or real expression has taken place.

SELF-EVALUATION

Self-evaluation is the most important kind of evaluation and the kind that the adult should do everything to encourage. Ritson and Smith (28) make a strong point when they say that only the child can successfully evaluate his or her work, since only the child knows the full intention. Also, the child is the one who knows whether the work is complete or not.

There are ways in which the adult can lead children to make their own evaluations. We want to work for their reliance on their

Lead children to make their own evaluations.

own judgment rather than that of someone else. We want children to respond to internal rather than externally imposed criteria. One good way to encourage this kind of judgment with children of 6 years and up is to place two or three pieces of their work alongside each other and ask which they think is better and why.

Thought-provoking questions can help children appraise their own work. They might include

"Have you put into the drawing all that you want to show about the subject?"

"Have you used colors to emphasize what you want to emphasize?"

"Do all the parts of the picture look like they belong together?"

"Does it put across the mood you want to express?"

Of course, these questions would not be asked of the pre-schooler. Remember, too, that self-evaluation can be encouraged during the process, not only at the end.

DISPLAYING CHILDREN'S ART

If all the work is exhibited in a place where study is possible, much self-evaluation will result. It will stimulate children to see their artwork displayed. However, it tends to distract attention from the experience to the final product. The younger the child, the more the attention should be kept on the experience.

When parents are displaying a child's work, they should hang all of it or let the child make the selection. If the parent hangs just one picture, this signifies a preference and can influence the child to do others like it in order to please. The child may become repetitious of one style and unable to enjoy flexible experimentation. One resourceful parent, with a prolific child and limited hanging space, took snapshots of the paintings and displayed them in the kitchen. The pictures also served as a good record of the child's art growth when later put in a scrapbook.

In the classroom, if the teacher displays only the work of the best students, the growth of the others can be hindered. One teacher, lacking space to display all the children's work, selects a few at a time. She often displays the work of problem students and finds that this results in a better attitude on their part—toward art and all classroom activities. Confidence built in one area transfers to other areas.

A great help in evaluating a child's artwork is to save all of it. This can be most useful later for understanding the child. And the child, looking back at the artwork, gains a real feeling of achievement. The parent or teacher, wanting specific checkpoints for evaluating a child's art growth, can refer to pages 54–59 of *Developing Artistic and Perceptual Awareness* (19). There, lists are given for age groupings, along with danger signals to look for.

A final reminder: Wherever there is grading, or any form of external evaluation, there is a tendency to "play it safe" and hence miss the opportunity to grow.

Grownups never understand anything by themselves,
and it is tiresome for children
to be always and forever explaining things to them.
The Little Prince

To see a child's work, one must be gifted with inner sight.
The child has an idea. He is going to create a lovely perfect thing.
The crude, crumpled thing he holds to your view
is the incarnation of his dreams. He sees the dream
and you just call on your inner sight and see it with him.
Otherwise there arises a great wall between you
and you and he are strangers.

ANGELO PATRI

the creative climate

JUST as there is a best climate for growing each variety of vegetable or fruit, there is a climate in which children may best develop creatively. By climate, we mean the conditions that enable creativity to happen. By creativity, we mean the ability and willingness to produce something that is new to the individual.

All children are born with creative ability. It is up to us to see that they retain as much of it in their later years as possible.

What makes a child more creative? "Anything which makes him more free and alive," answers E. Paul Torrance (62) one of the prominent writers in the field of creativity. Besides freedom, a child's creativity is nurtured by the warmth and affection of the significant adults in his or her life. All of us, especially children, tend to create for those we love (61).

Psychologist Carl Rogers (59) says that if human beings are to behave creatively, they must have psychological safety and psychological freedom. *Psychological safety*, he says, may result from three associated processes.

1. Accepting the individual as of unconditional worth, which implies faith in him (or her), no matter what his present state. This makes for a climate of safety in which the individual senses that he can be whatever he is. (This will be discussed in more detail later in this chapter.)

2. Providing a climate in which external evaluation is absent. Evaluation is a threat and creates a need for defensiveness, whereas an atmosphere in which one is not being measured by some external standard is enormously freeing. The purpose is to get the focus of evaluation within the individual. The guiding adult is free to react (I don't like your behavior) but not to evaluate or judge (you are bad). The difference is subtle, but this last statement puts the child at the mercy of outside forces and inhibits creativity.

3. Understanding empathically, which means trying to see the world from another's point of view and still accepting him.

The *psychological freedom* that fosters creativity permits the individual a complete freedom of symbolic expression. He or she is free to think, to feel, to be whatever is most within him- or herself.

The individual's behavior may need to be limited by society, but the symbolic expression need not be limited. In other words, the child must feel secure enough to try new things and be permitted the freedom to do so—within limits.

Along with the freedom to be themselves, youngsters need adult reinforcement of their creative efforts. These efforts need to be encouraged, accepted, and respected. Any effort that is sensitive and honest and unique should be rewarded in some way. In a creative climate, adults and children value uniqueness not comformity, differences not alikeness. One creative college student confided that she was raised on the advice "Think of how everyone else might do a thing and then see if you can't do it differently."

How different this is from the following all-too-often-heard statements:

"Whoever heard of doing it like that?"

"Where did you get that silly idea?"

"It's just not done that way!"

Statements of this type discourage creativity because they undermine self-confidence and courage, two most necessary ingredients.

Demeaning vs. Encouraging Comments

Other examples of demeaning statements to avoid are

"Can't you ever do anything right?"

"Whoever heard of a green cat?"

"You do it and I'll give it the finishing touches."

"Owls are for Halloween—not for Easter."

"You'll only lose it."

"Don't ask such stupid questions!"

"You've wasted a whole tablet!"

"You're biting off more than you can chew."

"Act your age!"

"It's not going to be as easy as you think."

"Don't begin something you can't finish."

"Here let me do it—you're a slow poke."

"Stay out of the Scotch tape!"

"That's a dumb thing to use it for!"

"Why don't you ever think?"

"Why can't you be careful?"

"You can't change the rules of the game."

"Is that all you can do?"

"Remember, everything you get out, you have to put away."

"How many times do I have to tell you?"

"Can't you see I'm busy? Don't bother me!"

"Why do you waste your money on something like that?"

"That's not the way to use that toy."

"Must you always take things apart?"

"You're so clumsy—you'll break it!"

An overdose of such statements can have a damaging effect on the self-concept and in turn can affect one's achievements. Let us not use demeaning words and thoughts on ourselves either. We do not want to undermine our own self-esteem and creativity. How much better to use such encouraging comments as the following:

"I like your idea because it's different."

"It's fun to try it different ways."

"Everyone makes mistakes."

"We learn by our mistakes."

"You can do it if you keep trying."

"Try it a few times and then it will seem easier."

"That's a good idea!"

"What can you think of to do with it?"

"How nice that you could figure it out for yourself!"

"We'll clean up the mess together when you're finished."

"I'm proud of you when you try hard things."

"You're just as capable as the others in your class."

"You do that very well."

"Show me how you came to this conclusion."

"Have you thought of some alternatives?"

"Whatever you decide is fine with me."

"Try it yourself first and then if you need help, I'll help you."

"If I do it, it won't be yours."

"I have to give you credit for working so hard."

"You're improving in _____."

"It's okay if you get dirty."

"Let's try anyway."

"You really know how to use your imagination."

"You do a good job of _____."

"I can see that you're trying."

"I'm glad you can do it."

"No, I'm not too busy to listen—tell me about it."

As Ann Wiseman (115) says, parents and teachers "hold the success of children in their tone of voice and generosity of understanding." We need to minimize the mistakes and emphasize the good things they do to give them faith in themselves. Effort should be commended, whether successful or unsuccessful.

Judgmental statements need to be carefully avoided because

they damage the self-confidence. Whatever squelches self-confidence will stifle creativity.

Expectations

So much of encouragement can be accomplished through the subtlety of our expectations. In important ways, people will be what we expect them to be, or at least behave as we expect them to behave. Over 200 research studies have shown that in carefully controlled experiments, the expectations of the researcher will influence the behavior of both people and animals. One well-known study found that when teachers expected randomly selected elementary students to show great promise, the I.Q. of each student increased significantly. Widely known as the Pygmalion effect, the self-fulfilling prophecy shows that parents and teachers need to be fully aware of their expectations.

The cliché that "more is caught than taught" is most applicable here. In their study of 400 eminent people, the Goertzels (47) found a strong drive toward intellectual or creative achievement present in one or both parents of the person, along with a restless, curious, experimental, seeking attitude.

Home Environment

A four-year study of homes that made efficient use of ability, found that a mother who has high but realistic expectations for her young children and a father who is not overpowering make a good combination for producing a creative environment.

Other research shows that creative youngsters seem to flourish in a home atmosphere where their responsible behavior is assumed rather than demanded by their parents. In the homes of creative youngsters, there was considerable less disciplining and fewer regulations, but more parental confidence and trust than in the homes of those who were equally bright, but less creative.

A home atmosphere that encouraged inquisitiveness and a sense of wonder seemed to be common with most "creatives."

Nor was fantasy eliminated from their lives. So, allow children to indulge in fantasy, both in the books that are read to them and the stories they tell. Adults with low levels of creativity usually had parents or teachers who deprived them of the pleasure of fantasy at an early age. Keeping the imagination alive is particularly important, for any activity that is truly creative originates in the imagination. As has been said, "Reason can answer questions, but imagination has to ask them."

Providing Stimulation

There is so much that parents and teachers can do in the area of imagination stimulation, if they first apply a little of their own imagination to the problem. Stretching the imagination with "What if?" and "Just suppose" fantasies is a good place to start for adult and child alike. Encourage playing with ideas, toying with things, and just plain silliness.

Since so much creating is of a problem-solving nature, more activities of this type need to be encouraged. These can range from allowing youngsters to participate in family decision making, to permitting them to do everything they are capable of doing for themselves. This helps them to grow in self-worth. Jumping in and doing for them, including making their decisions, gives them a feeling of being "less than" or inadequate. They must be allowed occasionally to experiment with their own way—possibly even a wrong way. Resist giving an answer when a child asks, "What shall I make (or do)?" Spend the effort necessary to get the child to give his or her own answer. Questions are to be encouraged, so also is helping them to find their own answers. Research shows that highly directive adults have an inhibiting effect on a child's creative expression.

Children who are overprovided for, both in terms of activities and prefabricated materials, lose out on a lot of problem-solving experience. Their environment should, of course, have basic materials accessible for exploring, experimenting, and constructing, but they should be encouraged to search out their own materials too. An abundance of materials seems to be an important part of the encouraging climate. The physical environment that promotes creativity is cheerful, colorful, challenging, and stimulating of curios-

Materials and a place to work are an essential part of the creative environment.

ity. That child is fortunate who has an area of his or her own that invites experimentation because there are materials at hand and things can be left out while still in use. A creative climate provides privacy for thought and study, which can be undertaken without fear of interruption. The encouraging adult will see that there is a minimum of interference when a child is absorbed in a project.

The Time Factor

Of utmost importance is the necessity of maintaining a balance of input and output time and allowing periods of "time-out" as well. Parents must help the child to alternate the process of giving out and taking in, as both the active and receptive states are necessary to producing creatively. If a child's school day is primarily a time of taking in, then time must be planned at home for giving out. Instead of passive viewing or reading, opportunity should be provided for art activities, play time, puppetry, creative dramatics, or games that require thinking, to name only a few possibilities.

Time-out periods are especially valuable for encouraging creativity. The normal activities of life are suspended, and the young-

ster has free time to live quietly with his or her own thoughts. Time-out generally takes one of three forms:

1. Extended—a dropping out of routine life for a while, through a trip, vacation, or long illness.
2. Random periods of daydreaming, reverie, reflection.
3. Regular quiet times for focusing inward—for centering, for getting beyond the conscious mind to the wealth of ideas that exist in other levels of consciousness. Encouraging such meditative states is giving a powerful boost to the creativity of the next generation.

One more use of time should be noted. It is important to permit a youngster to focus time and attention when beginning to show strong inclinations in a particular direction. This is a funneling of creativity, so that it becomes distilled and refined. History shows that stubborn youngsters who are "problems" because they will not scatter their energies are the ones who usually make the giant steps forward that change life and the world. "It takes an enlightened stubbornness to produce anything" (47).

Let us consider allowing the child his or her area of success, unburdened by subjects that cause failure and frustration.

Sensory Awareness

Another aspect of the creative climate is that it develops sensory awareness. Awareness refers to the simple consciousness that one is seeing, hearing, touching, tasting, and smelling. It is using the eyes, not only for seeing, but also for observing; the ears, not only for hearing, but for listening; and the hands, not only for touching, but for feeling. This kind of awareness is the foundation of creativity. To use the kaleidoscope analogy, it puts the pieces in the drum that the creative thinking process will then revolve.

The creative climate exposes children to experiences that make their ability to perceive more sensitive and stimulates awareness by such questions as:

"Did you see the pattern in the sand?"

"What does that smell remind you of?"

"Can you tell me the shape of the flower petal?"

"What things feel rough to your feet?"

"What things are yellow?"

"What is the quietest sound you have heard?"

"Where does the sound come from?"

"What do you see when you look out your bedroom window?"

"What is the smallest thing you saw today?"

"Does this feel smooth or rough to you?"

"What is a pleasant touch to your feet?"

"What does the house smell like when you first walk in?"

"Notice the smell of the Christmas trees."

"What is the sweetest taste you have tasted?"

"Of all the sour tastes, which do you like best?"

"What is your nose smelling now?"

"Let's be quiet and just listen for what we can hear."

The importance of the senses as related to art is beautifully stated in the following excerpt from Lowenfeld (22):

All art experiences are first perceived through our senses. . . . We cannot start early enough in life. There are no limitations. Expose the baby to the lulling noise of a brook; make him conscious of it by saying, "Listen." Let him listen to the singing of a bird, the rushing of the wind through the trees. Make him aware of the brittle sound of the fall foliage under your feet. Let him hold and touch whatever the opportunity offers. Open his eyes to whatever you are able to take in. One of my most precious memories is the moment in my childhood when I walked with my mother through the fields and saw miracles of nature she made me see.

Whatever you can do to encourage your child in his sensitive use of his eyes, ears, fingers, and entire body, will increase his reservoir of experience and thus help his art.

The Creative Attitude

Most of this chapter has suggested that "creativity is not so much an aptitude as an attitude," and, as with most attitudes, it may be imprinted at a very early age. If parents can encourage and strengthen this attitude while the child is young, his or her individuality may survive the conforming years.

The pressures for conformity are greater than ever. The Groetzels (47) tell us that today's parents of gifted children are subject to stronger pressure to have the child conform to mediocrity than were the parents of the eminent four hundred whom they studied. Anthropologists say that ours is the most peer-oriented culture in the world, and the child becomes almost afraid to think until he learns what his classmates are thinking. For this reason, creative thinking is at its peak in about the second grade and dwindles off and reaches a low point in high school for many youngsters.

The challenge is to give the child such faith in his or her uniqueness that he or she will be able to go through the socializing process and retain the creativity needed in today's world.

Self-esteem

The answer to retaining creativity lies in building a sound self-esteem. The climate that builds self-esteem is the same climate that encourages creativity, and vice versa. Self-esteem has been defined by Barksdale (35) as "how one actually feels about himself, based on his individual sense of personal worth and importance." It is usually a subtle feeling that one is not conscious of. High self-esteem, Barksdale defines as "unconditional self-acceptance (despite one's mistakes, defeats and failures) as an innately worthy and important being."

It is the kind of feeling that is necessary for high creativity, because creativity, by its very nature, involves a lot of risk taking. Torrance (62) reminds us that "It takes courage to be creative. Just as soon as you have a new idea, you are a minority of one." This kind of confidence can be instilled by esteem building. As Dorothy Briggs (38) so well states, "The child whose experiences have taught him that he is unconditionally loved and worthwhile

is free to listen to his inner promptings, he trusts his personal reaction and intuition."

Creativity calls for an openness to new experiences, a social independence, a willingness to stand up for one's own ideas and opinions. One with high self-esteem has this kind of confidence and independence, whereas one with low self-esteem finds conformity less risky than creativity. Those with low self-esteem, according to Briggs, will set aside their own ideas in favor of the

Creativity requires a willingness to stand up
for one's own ideas and opinions.

approval of others and, being threatened by the unknown, will shy away from independent decisions and responsibility and leadership. They are very sensitive to criticism because they feel their lovability is contingent upon performance. Because they feel that they are what they do, they are not free to take the risks that real creativity involves. Those with high self-esteem separate themselves from their performance and know that their lovability and worthiness are not dependent upon it. Therefore, they can be open to new experiences and ideas, can take risks, and be independent in their thinking.

So much more could be said about the relationship of high esteem to creativity, but let it suffice that those interested in nurturing creativity should do everything they can to build a foundation of confidence and total self-acceptance. Besides the two excellent authors already mentioned, teachers might wish to study the books in the Bibliography by Canfield and Wells, Purkey, and Elkins, along with many other good books available on self-esteem.

Self-esteem is contagious and is passed on from generation to generation. The best thing we can do to raise our children's self-esteem is to raise our own because they model after us. Barksdale says, "Good self-esteem is the most precious gift a parent can give his child."

No printed word, nor spoken plea
Can teach young minds what men should be.
Not all the books on all the shelves—
But what the teachers are themselves.
Anonymous

Any situation is a chance to teach others
what you are, and what they are to you.
A Course for Miracles:
Manual for Teachers

Following is a checklist that can be used to analyze whether we are encouraging or inhibiting the release of creativity in children.

ENCOURAGING ADULT VS. INHIBITING ADULT

The Adult Who Provides an Encouraging Climate:	*The Adult Who Provides an Inhibiting Climate:*
—Shows unconditional acceptance of self and youngsters.	—Shows conditional acceptance of self and others.
—Departs from regular routine.	—Maintains rigid routines, fixed requirements, time limits.
—Follows interests of children instead of imposing own ideas.	—Instills feeling that a predetermined response is expected.

ENCOURAGING ADULT VS. INHIBITING ADULT—*Continued*

The Adult Who Provides an Encouraging Climate:	*The Adult Who Provides an Inhibiting Climate:*
—Maintains emphasis on intrinsic rewards.	—Uses extrinsic rewards that are unsuitable.
—Encourages children to try out their ideas, challenges them to do so.	—Rejects new ideas, has closed mind to unusual approaches, prefers "tried and true" methods.
—Is more concerned with the child than the subject.	—Is more concerned with the subject than the child.
—Focuses on the process.	—Focuses on the product.
—Shows humor in approach.	—Has little time for humor or play.
—Stresses independence of thought that encourages individual initiative and decision.	—Promotes dependence on the approval of others and fear of authority.
—Allows time for thinking, discovery, experimentation, playing with ideas.	—Has time schedules and pressures, wants "right" answers.
—Encourages testing, comparing, and examining ideas.	—Encourages referring to an "authority."
—Stresses the divergent thinking process.	—Puts emphasis on the convergent thinking process.
—Plans for individual differences and offers small group or individual instruction.	—Uses mass instruction or handling.
—Uses democratic practice in home or classroom.	—Uses autocratic or pseudodemocratic practice.
—Tries new methods of doing things, of approaching learning.	—Is habit bound. Depends on previous routines that have been established as workable.
—Uses open-ended questions and permits estimating and guessing.	—Asks "right answer" type questions, tells the right answer to save time, penalizes the wrong answer.

ENCOURAGING ADULT VS. INHIBITING ADULT—*Continued*

The Adult Who Provides an Encouraging Climate:	*The Adult Who Provides an Inhibiting Climate:*
—Allows child to complete tasks to a place where child is satisfied, encourages learners to make own judgments.	—Requests that a task begun be finished to the satisfaction of the adult.
—Provides a climate free from excessive competition, anxiety, or coercion.	—Encourages physical, social, or emotional competition.
—Has high degree of expressiveness and encourages this in youngsters.	—Is "closed off."
—Understands that the highly creative child is the one most likely to deviate from what is expected of him or her.	—Is irritated and upset by the "creative" and considers child a nuisance.

*The most deadly of sins
is the mutilation of a child's spirit.*
ERIK ERIKSON

Probably, the "creative climate" is well summarized by the following quote from Dale Baughman (36): "Every person needs recognition. It is expressed cogently by the lad who says, 'Mother, let's play darts. I'll throw the darts, and you say "wonderful." ' "

How often the child may wish to say, "Teacher, let's paint. I'll make the picture, and you say 'wonderful.'"

The encouraging climate at home or school is generous with "wonderful."

Genuinely creative thinking, in any field,
is done on an "abstract" level;
it is a product of flights of fancy
(of often seemingly ridiculous extremes)
unlimited by practical considerations. (33)
WANKELMAN AND WIGG

9

understanding
the creative process

WHAT is the process through which creativity emerges? The process of producing new ideas and new forms is significantly different from the process of learning existing knowledge. Where children are concerned, the process is more important than the product. The product may be a short-lived thing, but training in the process can be a valuable aid all through life.

Since creativity is a way of thinking, and habits of thinking become attitudes, we can think of creativity as a process of attitude development. It is the attitude, along with the steps in the process, that can give the student access to countless ideas in his or her lifetime.

So often creativity for the young is associated with overpermissiveness, but even the young child must go through definite steps in the process of creating. First, the child must identify himself with the idea he is going to work on and become aware of its personal meaning. Second, the child must achieve control over the materials to be used, which necessitates some discipline. Next, the

child must organize the materials into forms that express his or her ideas.

There are generally accepted steps in the process of creating or creative problem solving. These steps are presented here so that the adult may better guide the child in the type of thinking that produces original solutions. Even the very young can be taught a simplified form of these steps, which are based on the works of outstanding leaders in the field of creativity, such as Alex Osborn, Sidney Parnes, and E. Paul Torrance, whose books are listed in the Bibliography.

The conventional steps have been modified slightly to make them more adaptable to classroom use. Some call this the deductive or mechanical approach to creativity, as opposed to the spontaneous. This is a direct frontal assault on the problem, whereas the spontaneous method awaits the sudden flash of insight. It is really rare for inspiration to come without some wrestling with the idea or problem. When there has been sudden insight, most of the steps have already been gone through unconsciously. Most simply stated, the creative process is a period of conscious working, which is followed by the unconscious working, which in turn is followed by conscious work again.

Even though creativity goes through distinguishable phases, these phases merge and blend, one into the other, at times. So, keep in mind that the following steps are *not* like stair steps, where one has to follow another. There is much overlapping.

BASIC STEPS
IN THE CREATIVE PROCESS

The eight basic steps in the process of creating and problem-solving are:

1. Initial Awareness
2. Expectant Attitude
3. Preparation
 a. Problem Definition
 b. Data Gathering
4. Creative Ideation
 a. Divergent Thinking
 b. Deferred Judgment
 c. Extended Effort
5. Incubation
6. Illumination
7. Evaluation
8. Execution/Action

Each step is discussed in detail in the following pages.

1. Initial Awareness

This step is characterized by

- The impulse to create.
- An awareness of a problem to be solved.
- A vague feeling of an idea to be realized.
- A notion of something to be done.

This is the stage that is triggered when the teacher announces, "We're all going to make a painting of a favorite activity" or the parents suggest that the child "make something for grandmother."

2. Expectant Attitude

This is an important factor to inject continually into the creative process. It is hard work to create something new and definitely requires an "I can do it" attitude. It is especially important initially, once there is the impulse to create, to think in terms of I am, I can, I will, I am capable, I can do this, I will achieve what I've set out to do.

A positive expectation that one is able to bring forth fresh ideas and carry them through to successful completion is necessary to creativity. Parents and teachers, by example and otherwise, can teach positive, expectant attitudes to children.

3. Preparation

This step usually involves two parts, and they often overlap, in that the first can lead to the second and back to the first.

Defining the problem The creator needs to have clearly in mind what he or she wants to achieve, what the problem really is, from his or her point of view. As Charles Kettering, the electrical genius of General Motors, once said, "A problem well defined is half solved." Many times we have not recognized the real problem, which may be underneath the problem we think we are trying to solve. With children whose challenges tend to be noncomplex, just being asked by an adult what they are trying to do may be enough to define the problem in their minds. Sometimes their problem might simply be, "Do I draw this to please me or to please my teacher?" Through a process of questioning, the adult can help children be more clear about the task or problem, and lead them to the broadest possible statement of it. The more broadly stated, the more room there is for new ideas. Since problem definition is vital in the adult world, it would be well to establish this habit of thinking in early life.

Data gathering This is the important fact-collecting stage. "We can have facts without thinking, but we cannot have thinking without facts," said renowned educator John Dewey. At this stage, the child questions, inquires, experiments, manipulates, discovers,

tests ideas, and weighs evidence. This requires careful observation with all the senses and complete objectivity. The adult can do a lot to help the child in this data-gathering stage, both short and long term. To explain this, the kaleidoscope analogy of Parnes (56) is fitting. All the sensory input and facts the child is exposed to become like the pieces in the kaleidoscope. The revolving of the drum is compared to creative thinking. The more pieces that are in the drum, the more intricate patterns (ideas) can be formed. The teleidoscope is an even better analogy, because there is nothing in it to create with initially. It must be focused onto a richly patterned environment—not a plain wall—to have anything with which to work.

Whether the subject is art or something else, the adult can help children gather the information that is needed all during the creative process. Often new data will put a whole new slant on the problem and inspire new definition.

4. Creative Ideation

In a group, this step is often called brainstorming or imagination storming. Children need to have practice in this, both as an individual process and as a group activity. This is the phase of the creative process where alternative ideas are piled up. It is the idea-gathering stage as compared to the data-gathering stage.

Most people fall short of their creative potential because they grab the first idea or solution that presents itself. But the first idea, research shows, is usually trite and ordinary. Children can be taught to bypass their first ideas and to consider many alternatives before making a decision.

There are three principles of ideation which can be applied to improve the quality of ideas gathered. They can be taught to children at an early age.

Divergent thinking This is the kind of thinking that moves in several directions at once and produces many different answers. It does not converge on an absolute or correct answer, as does convergent thinking. It uses the knowledge, facts, concepts, and skills gained through convergent thinking to create new answers.

This lateral-type thinking escapes the channel of "traditional response" and explores alternative ways of looking at things.

"Forced relationships" is a powerful exercise to stimulate divergent thinking. The idea is to combine or associate things or principles that are not commonly associated. This stretches the imagination and breaks up old patterns of thinking. One teacher wrote names of objects on slips of paper and had the children draw two slips each from a basket. They were then asked to force a relationship between the two diverse objects. Older children can

Divergent thinking is encouraged by finding a relationship between two normally unassociated objects. Here the objects are named on the slips of paper.

be challenged to relate three or four objects to create a new idea. The list of objects one can use is endless—toothbrush, window, paper, basket, book, vase, potato, typewriter, and so on.

Deferred judgment This is a most important principle of the ideation or brainstorming phase. Judgment of any of the ideas is postponed in order to prevent hampering the imagination. It is also called the anxiety-removing principle. This provides a facilitating climate, internally and externally. It is just as important to teach youngsters to postpone judgments when they are working alone, thinking up ideas, as when they are brainstorming with a group. The creative side of the brain does not work well when the analytical side is in operation. Teaching youngsters to "think up" now and judge later will be a boon to them all their lives.

Extended effort This is based on the proven premise that "quantity breeds quality." Many studies have shown that the greater the number of ideas, the greater the likelihood of winners. As Linus Pauling put it, "The best way to have a good idea is to have lots of ideas." To help children generate lots of ideas, the idea-spurring questions presented by Alex Osborn and re-arranged by Robert Eberle are useful. They can be applied to things, thoughts, themes, principles, talents, and more.

In his book *Scamper,* Eberle (44) suggests running playfully about in the imagination with the Scamper Techniques set forth in the table.

SCAMPER TECHNIQUES WHICH LEAD TO IDEAS

S	Substitute	To have a person or thing act or serve in the place of another.
C	Combine	To bring together, to unite.
A	Adapt	To adjust for the purpose of suiting a condition or purpose.
M	Modify	To alter, to change the form or quality.
	Magnify	To enlarge, to make greater in form or quality.
	Minify	To make smaller, lighter, slower, less frequent.

SCAMPER TECHNIQUES WHICH LEAD TO IDEAS—*Continued*

P	Put to other uses	To be used for purposes other than originally intended.
E	Eliminate	To remove, omit, or get rid of a quality, part or whole.
R	Reverse	To place opposite or contrary, to turn it around.
	Rearrange	To change order or adjust, different plan, layout or scheme.

An authoritative book in the field of creative problem solving is *Applied Imagination* (54), which devotes several chapters to idea-spurring questions that both child and adult can use to generate a quantity of ideas. In checklist form, they are as follows:

PUT TO OTHER USES? New ways to use as is? Other uses if modified?

ADAPT? What else is like this? What other ideas does this suggest?

MODIFY? Change meaning, color, motion, sound, odor, taste, form, shape? Other changes?

MAGNIFY? What to add? Greater frequency? Stronger? Larger? Plus ingredient? Multiply?

MINIFY? What to subtract? Eliminate? Smaller? Lighter? Slower? Split Up? Less frequent?

SUBSTITUTE? Who else instead? What else instead? Other place? Other time?

REARRANGE? Other layout? Other sequence? Change pace?

REVERSE? Opposites? Turn it backward? Turn it upside down? Turn it inside out?

COMBINE? How about a blend, an assortment? Combine purposes? Combine ideas?

To get children used to this kind of thinking, one teacher had them draw a basic shape and then apply the Scamper techniques. The drawing shows what might happen with a triangle.

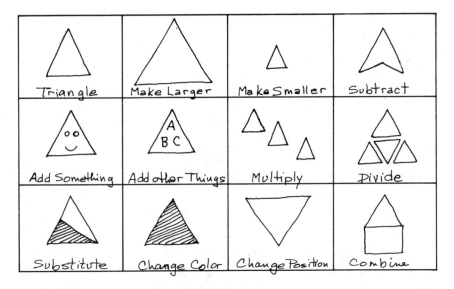

Another technique is to place a simple object, such as a common toy, in front of the children and have them apply the idea-spurring questions to it. A teddy bear, ball, jumprope, or toy car will work well. Children can take turns in bringing toys for this group exercise in Scampering. Of course, the principle of deferred judgment should be kept in mind.

Children can have fun going through magazines and newspapers looking for Scamper examples. In school, a Scamper principle can be assigned each week, with children bringing in as many magazine pictures and objects as possible to illustrate the concept. The more children become used to looking at things this way, the more they will automatically apply this thinking to all areas of their lives.

5. Incubation

As already discussed, the creative process is primarily conscious work, followed by the subconscious working, followed again by conscious work. The incubation period is where we put the subconscious to work. During this stage, we let the facts and ideas simmer in the mind and do not attempt conscious thinking with respect to the problem. The belief is that the creative power of

the subconscious mind will not go to work on the task or problem while the conscious mind is wrestling with it. We must "let up" to invite illumination.

Although incubation is aptly called the "do nothing" stage, it is vital to the creative process. Parents and teachers need to understand it and provide for it. It is the reason that many artists work on more than one art project at a time. When they are in the incubation stage on one, they can be actively working on another. So, when children have been on a problem for some time without seeing a solution, help them to incubate it for a few minutes, hours, or days.

6. Illumination

This stage is sometimes described as the "Ah-ha!" or "I've found it!" experience. It is where insight—unexpectedly, almost miraculously—breaks through. One teacher has an "ah-ha" section marked off on the blackboard, and anytime a student has an "ah-ha" to be shared, he or she puts his or her name on the board. Daily, the whole class has "ah-ha" sharing.

Older children can be advised to keep an "idea trap" (notebook and pencil) always available, so they can trap insights before they are lost.

7. Evaluation

The ideas that have come up during creative ideation and illumination must be evaluated to decide which one best answers the need or concern. Usually, it is useful to have a set of criteria against which to measure each of the ideas. Even the very young can be trained to use both judgment and visual imagination to evaluate their ideas. It is at this stage of the creative process that one puts aside divergent thinking and returns to convergent or vertical thinking. Piaget (46a) says, "the second goal of education is to form minds which can be critical, can verify, and not accept everything they are offered. The great danger today is of slogans, collective opinions, ready-made trends of thought."

8. Execution/Action

This is the stage of labor or deliberate effort. Youngsters can learn early that ideas are plentiful, but that only when they actually do something with them are they winners. It has been aptly said that the creative process only *begins* with an idea. Too often, people let it end there, and much that could be of benefit never gets executed. Let us encourage this action stage.

It is doing something with ideas that counts in life.

There should be a final step added to the creative process—that of enjoying the results. How often people do not give themselves that pat on the back they deserve for their accomplishments.

The creative mind barely achieves a goal or realizes an accomplishment before it is involved in new challenges and initiating the creative process all over again. Or, as C. W. Taylor (49) states: "A creative mind continually reaches toward new designs, new patterns, new insight; there is an almost endless freshness in its inexhaustible powers. One new design is replaced by another, and then still another."

Probably the best way for adults to understand the creative process is to get personally involved in creating. Just as good ath-

letes go through warm-up exercises to stimulate their muscles, teachers need to limber up their creative thinking muscles so that they do not atrophy. The "Teacher Creativity" chapter of *Creative Activities Resource Book for Elementary School Teachers* (62a) is full of such limbering up exercises to help teachers free their minds and "flower" as creative individuals. According to the author, adults who say "I am not very creative" are admitting that they stopped risking themselves long ago because they didn't receive rewarding feedback. Through an experiential understanding of the creative process, parents and teachers will be in a better position to give children rewarding feedback.

Creative children look twice,
listen for smells, dig deeper,
build dream castles, get from behind locked doors,
have a ball, plug in the sun,
get into and out of deep water,
sing in their own key. (61)
PAUL TORRANCE

10

profile
of the creative child

THE PRINCIPAL GOAL of education, according to Piaget, is "to create men who are capable of doing new things, not simply of repeating what other generations have done—men who are creative, inventive, and discoverers" (46a).

Creativity is a birthright. Everyone is born creative, but the potential must be developed. There is a wide range of creativity, just as there is a wide range of intelligence. It exists in everyone in varying degrees, on a long continuum. Children should have an equal chance to express their creativity, but they should not be expected to be equally creative.

Creativity is not a single quality but stands for a group of related abilities, such as fluency, originality, and flexibility. Because these abilities are often used together, they have come to be grouped under a single term. It is the same with the creative person. The total personality is made up of many attributes, skills, and qualities, which together make for a creative individual. No one child would necessarily be strong in all the characteristics, even though highly creative. Also, it is possible for a child to have a few of the attributes

and not be especially creative. What is presented here is a general profile of the creative person, the creative child in particular.

ATTRIBUTES
OF THE CREATIVE CHILD

Dorothy Briggs in *Your Child's Self-Esteem* (38) presents the question, "What characteristics distinguish creative youngsters from non-creative ones?" Here is her concise and lucid answer:

> Creative children tend to be independent, rather unconcerned with group pressures or conformity, and disinterested in what other people think of them. They retain their capacity to wonder and question and see things afresh. They are flexible, imaginative, spontaneous, and playful in their approach to problems. They are highly receptive to their senses; they tend to see more, feel more, and drink in more of what is around them. Creative youngsters are equally open to

themselves and what is going on within. In short, they are highly responsive to both their inner and outer worlds.

Such children are willing to risk paying attention to intuition and trying the new. It requires a certain degree of confidence and security to work with the disorganized, the complex, the inconsistent, the unknown, and the paradoxical. Creative youngsters are not particularly concerned with neatness or promptness and are easily bored with routine.

Charles Schaefer gives us another look at the creative child, saying the same types of things in a different way. His list of ten characteristics is from *Developing Creativity in Children: An Idea Book for Teachers* (60). He prefaces it, "The highly creative person is, of course, a complex individual with a wide variety of abilities and traits. Certain of these characteristics which appear from the earliest years are":

1. *Sense of wonder; heightened awareness of the world:* The creative person shows fresh, childlike awe and awareness of the external world. He constantly uses all of his senses and notices the usually unobserved nuances of his environment.

2. *Openness to inner feelings and emotions:* He is spontaneous, impulsive, and uninhibited; he talks easily to adults about what he thinks and feels. His drawings show an open flood of feelings.

3. *Curious, exploratory, adventuresome spirit:* He is curious about his environment and toys with objects and ideas within it.

4. *Imagination:* Imagination is the power of forming mental images of what is not actually present to the senses, or has never been actually experienced; or of creating new images by combining previously unrelated ideas. Imaginative thinking is picturesque, vivid, and colorful. It adds a sense of immediacy and vitality to experience. Children arrive at the ability to imagine and play make-believe games long before they reach the stage of logical, abstract thought. Eidetic imagery—the forming of clear, visual images of objects previously seen but no longer present to the senses—is quite common in children but rare in adults. Eidetic images are clearer and richer in detail than the usual memory image. They reflect the research finding that shows that imaginative thinking peaks in childhood and shows a steady decline in adolescence and adulthood.

5. *Intuitive thinking:* Intuitive thinking is the solving of problems

without logical reasoning. The intuitive thinker is open to hunches and is able to make good guesses.

6. *Independent thinker:* A non-conformer who is confident in his own standards of judgment and would rather find things out for himself than accept them on authority.

7. *Personal involvement in work:* The creative person identifies with a task so that he becomes totally absorbed in and dominated by his work. He enthusiastically engages in tasks that are personally meaningful and satisfying.

8. *Divergent thinker:* As opposed to convergent thinking, which seeks the one right answer as determined by the given facts, divergent thinking is defined as the kind that goes off in different directions, that makes excursions from the beaten path, that seeks variety and originality, that proposes several possibilities rather than seeking one right answer.

9. *Predisposition to create:* Tendency to express things in an original idiosyncratic way rather than considering how things are supposed to be or always have been expressed. He seeks novelty, diversity, and originality in his environment.

10. *Tendency to play with ideas:* When presented with a novel, fantastic, or improbable idea, the creative thinker's first inclination is to mentally toy with the possibilities and implications of the idea. His tendency is to try to show how it might be true. The critical thinker, on the other hand, will immediately try to disprove such ideas and show how impractical or infeasible they are.

Creativity is not limited to the arts, of course, since the scientist, the salesperson, the teacher, the homemaker can be as creative as the writer and painter. Furthermore, just because a person earns his or her livelihood in the arts does not assure a creative individual.

The next list is another look at the generally accepted attributes of creativity, based on the writings of Kneller, (52) and others.

CHARACTERISTICS OF THE CREATIVE

1. Intelligence. Those with low or average IQs tend toward low or average creativity. For high creativity, one needs to be highly intelligent, but the reverse is not true—a high IQ does not guarantee high creativity.

2. Awareness. Creative persons are more than usually sensitive to their environment. They notice things that other people do not. They experience more because they are more open to their environment.

3. Fluency. This is indicated by the number of ideas one can produce, per unit of time. Other things being equal, the person who can come up with more ideas is also likely to produce more good ideas.

4. Flexibility. Being more flexible, the creative person will try a variety of approaches to a problem and will shift easily to meet new situations when required.

5. Originality. This refers to the uncommonness of response, cleverness of response, and remoteness of association.

6. Elaboration. The creative person not only has novel ideas, but follows them through to creative achievement.

7. Combination of skepticism and credulity. Compared to most people, the creative person tends to be more skeptical of accepted ideas and less suspicious of new ones.

8. Persistence. Creating requires strong motivation and hard work, since it must often be sustained over long periods of time and in the face of obstacles. Probably no one in our society works harder than the true creator, for even in sleep or reverie he or she is working.

9. Withdrawn and aloof. The creative person tends not to bother with close relationships. Children are often estranged from their peers and teachers, and inclined to work in isolation. They often do not have a buddy, nor are they chosen to be on teams or in work groups with other children.

10. Nonstereotyped sex identity. The creative person is not limited by popular beliefs such as girls should not be independent or boys should not be sensitive. Creativity calls for sensitivity (considered feminine by some) and independent thinking (considered masculine).

11. Self-critical. Rarely quite satisfied with himself or his work; on the other hand, the creative person is not easily discouraged or frustrated.

12. Humor. Creative people have the ability to see more meanings in a situation than does the ordinary person and are playful with ideas. The high I.Q., noncreative student is not as humorous as the highly creative person.

13. Nonconformity. The independent person is most capable of creative achievement because he maintains a balance between group centeredness and self-centeredness. Unlike the conformist, the nonconformist is original in his ideas. Unlike the counterconformist, he is unconventional, not for its own sake, but in the course of creativity.

14. Self-confidence/self-esteem. The creative person has an inner confidence in his worth and the worth of his work. Despite any troubles, he is sustained by a faith in his creative powers and value as a person.

15. Willingness to take risks. The creative person often has great personal courage (related to point 14). For instance, he can risk being laughed at because what is important to him is not what others think, but what he thinks of himself.

16. Not time-bound. Creative people do not work by the clock and tend to lose awareness of time. Time has a personal, not a social meaning, and such people do not respond well to "deadlines" set by someone else.

17. Sustained curiosity. A capacity for childlike wonder all during life is typical. He never stops asking, questioning even his most cherished ideas. Too much rigid faith in one's ideas does not allow room for making discoveries.

18. Emotional stability. Creative people are able to meet the unforeseen and figure out alternatives. They are resourceful and secure, which contributes to stability. Studies have shown that creatives are less anxious and neurotic as a group than noncreatives of the same I.Q.

Unfortunately, many studies show that neither parents nor teachers valued the characteristics that typify creative children nearly as much as they valued the more conforming characteristics of the high I.Q. children. These high I.Q. children are "success oriented" and "teacher oriented," while creative children generally are not. In his book Kneller (52) explains quite fully some of the uncomfortable traits that make creative children less attractive to teachers. For instance, they are often difficult to handle, being more independent; they are less friendly and communicative, being more self-absorbed; they are often less studious and orderly, being more interested in their own ideas than in assigned work. Being interested in ideas rather than presentation, their work can be un-

tidy and slapdash. They are likely to get involved in tasks and resent having to stop and move on to another subject.

These, and other "unattractive" characteristics, cause many teachers and parents to squelch the creative child, thus accounting for the great decline in creativity as a child moves up in school and into adulthood. Thus, an enormously valuable human resource is lost to the world.

> *We are all potentially creative,*
> *but only those who have become creative realize it." (48)*
> GOWAN, DEMOS, TORRANCE

PART TWO

ART PRACTICES

I hear, but I forget.
I see, and I remember.
I do, and I understand.
CHINESE PROVERB

PART TWO
ART PRACTICES

11
introduction to art practices

THE second part of this book deals with art materials and methods for those who work with young children, ages 3 through 8, with emphasis on preschoolers. However, the materials, methods, and philosophy can actually be adapted for children of most any age. In fact, they were successfully used by one educator in her work with prisoners, mental patients, and the handicapped.

Parents and beginning teachers often ask for some criteria by which they can judge a creative activity for preschool children. One answer is to ask themselves the following five questions before offering a project:

1. Is it unstructured—something the child can do on his or her own?
2. Will it develop the imagination?
3. Will it allow freedom to experiment?
4. Will it offer sensory experience?

5. Will it provide a feeling of success, of satisfaction to the child? "Success" here does not refer to satisfaction with the end product, but to the child's feeling of satisfaction with him- or herself.

The adult will need to decide which children can handle which projects. It is the developmental age, not the chronological age, that is relevant.

It is important in these early years to have the child explore a great variety of art materials, as they will stimulate the senses and imagination and increase the visual vocabulary. A word of caution is in order, however. Having new materials each day can lead to shallow experiences and superficial learning, because the child does not get to use a material often enough to grow in the use of it. So, avoid a large collection of gimmicky materials and allow the child to become more familiar with the basic media— media that may serve him or her throughout adult life. New materials will renew and stimulate the interest, but it is important to have the basic media available to be reused often. The simplest materials can often provide the deepest experience. As Pearl Greenberg (79) points out, revisiting basic ideas and reusing materials frequently are good in any curriculum development, be it music, science, social studies, or art.

It is important to provide some variety in the media offered for self-expression at any one time. The reason for this is that children have their different types of coordination developed to different degrees. If only crayons are available, the eye-hand coordination required might be too frustrating for some youngsters, and they are denied self-expression. Sponge painting or texture collages might offer more success to them.

Since we are exposing the child to a large variety of materials, it is often asked *how* each new material should be introduced. With some materials (and for some children) just setting them out is enough. The children eagerly explore and discover on their own. Sometimes a brief explanation is necessary, but with preschoolers it should emphasize one point only—a point that is crucial to achieving initial success. A brief demonstration may be included if it contributes to the one point being made and is done at the child's level of ability. Otherwise, the superior achievement of the adult may be discouraging to the child and cause him or her to become more of a watcher than a doer. It is best to destroy the demonstration pieces right away. The reader is referred to Chapter 6, where a great many ideas are presented for initiating an art project.

There is some controversy over whether one should teach children techniques or allow them to learn techniques by the longer process of experimentation. It is felt that they learn more by the latter method and achieve a greater feeling of success because they have set their own goals. In answer to those who would teach techniques to preschool children, Helen Heffernan (112) says, "Children must first learn to *do* something before they can learn how to do it." Generally speaking, children are ready for techniques when they ask for them—when they feel the need. They can use the same materials for a great many years and never become bored unless they are restricted in their use.

Piaget's work (46a) suggests that the teacher's major task is to provide for the child a wide variety of potentially interesting materials on which he may act. Piaget would not have the adult teach but encourage learning through the manipulation of things.

Also, remember that if the adult has to do too much of the work, the art project is not appropriate for the child's age level, and he or she is deprived of feeling that it is a personal piece of

art. This often happens in preschool co-ops where there are many adult helpers.

Finally, remember to display the work of *all* the children, since we are interested in developing the creative potential of *all*. Do not stress taking the work home; allow the child to make that decision. (See Chapter 7 for additional ideas.)

*It is said that the artist
is distinguished from the rest of humanity
by his constant visual awareness
of the world around him. (93)*

LALIBERTE AND MOGELON

12

looking and seeing

CHILDREN do not need to be busy every minute making something with their hands to be studying art. The basic elements of art are all around them, in both nature and man-made objects. These can be observed, studied, collected, compared, and appreciated. The world needs consumers of art as well as producers. Artist and consumer both need to *intently* look, touch, hear, and smell. Adults can help youngsters develop a sensitivity toward the things that surround them, an awareness of the elements of art—line, form, pattern, color, texture. The sensitive adult can lead the child to see more, both in greater quantity and greater depth. "Creation begins with vision," said Henry Matisse.

To awaken a child's awareness of beauty, one must first be aware of it oneself. Books such as *Discovering Design* (72), *Design in Nature* (80), *Forms of Nature and Life* (75), *Invitation to Vision* (20), *The Seeing Eye* (109a), and others are helpful for both adult and child. Exercises in perception will develop in children the habit of seeing what they are looking at. "Children cannot create out of a vacuum," as Natalie Cole (6b) so well states.

"LOOKING" ACTIVITIES

What are some looking-type activities? For starters, try the ones discussed on the following pages, then add more of your own. As you add more activities to the list, keep in mind that as awareness increases, so does one's ability to make good choices. Taste improves with this kind of growth.

- Try "looking walks" in the neighborhood, woods, beach, park, or even indoors. Make it a time of looking and touching, when youngsters really feel the textures around them. Begin with the adult picking up leaves, rocks, shells, and so on, and exclaiming over texture and color. Play dough can be taken along in which to stick gathered objects. Have children look for hidden spots of beauty, the tiny things that usually are not noticed. Compare the world to a giant painting, and let them know that walking

On "Looking Walks" children observe the basic
elements of art in nature.

into nature is like walking into a painting. Since nature is constantly creating the painting, they can take the same walk over and over and see a new picture each time.

- The "color walk" is a specific kind of looking walk where the focus is on seeing as many kinds of colors and shades of color as one can.

- "Listening walks" are a variation of the "looking walk" and are to encourage an awareness of the many sounds around us that we usually filter out. Such walks are best done holding hands with a partner. Turns are taken, with one child being blindfolded and the other being the leader. After the walk, encourage drawings or paintings of something that was heard, the predominant sound, or several sounds.

- Encourage children to bring "found objects" from nature and put them in a special box or on a table at school or at home. Additional awareness can be developed by having the children feel the objects with their eyes closed. This is "looking with the hands."

- Look for the beauty of line, form, pattern, color, shape, and texture in both natural materials and man-made objects. Study the commercial objects found in stores.

- Look for likenesses and differences in shapes, sizes, color, and such in the everyday objects around one.

Encourage looking with the hands as well as with the eyes.

- Collect nature materials to use in creative arrangements (seeds, weeds, cones). Some ideas for dough and paste collage using nature materials are found in Chapter 13.
- Collect textures—bumpy, soft, smooth, slippery, rough, fuzzy, scratchy, etc. See how many textures can be identified in pictures from magazines. Then find similar textures in real objects. Make a collection of texture rubbings (see Chapter 15 on Drawing and Rubbing).
- Select the most appealing designs from many patterns of drapery materials or wallpapers (from old wallpaper books), and look for the beauty in architecture. This can be supplemented by pictures in books and magazines.
- Catch spiderwebs on black paper (first spray the web with spray starch).
- Study the clouds, looking for objects in their shapes. Do the same with a collection of driftwood or rocks.
- Dip rocks in water to discover how they change color.
- Look at colors in a prism and in soap bubbles. (For bubbles, mix 1 tablespoon of glycerine, 1 tablespoon of detergent, and 5 tablespoons of water.) Use pipe cleaners shaped into wands, soda straws, mesh berry baskets, and funnels to "blow" the bubbles. (Sweep the large end of the funnel across the liquid and blow through the small end.)
- Play with colors:

 - Drop different colors of food coloring into a glass of water.
 - Add food coloring to granulated sugar—red, blue, yellow.
 - Drop paint colors on a wet surface so that they will run together.
 - Look through colored cellophane papers and place them over each other to mix colors.
 - Look at the effect of lights on color—black light, fluorescent light.
 - Play color matching games with color chips from paint or hardware stores.
 - Study a color wheel to learn about primary, secondary, intermediate, complementary, and analogous colors.
 - Teach color vocabulary (if the children are old enough)—light, dark, warm, cold, tints and shades, intensity, tone or value,

It's fun to observe the colors in soap
bubbles.

and hue. (An excellent chapter on color is found in *Creative Art for the Developing Child* (68).)

- Get an "arts-eye" view of things by changing scale and perspective. The familiar can be made extraordinary. Lie down on the floor or grass and look up. Stand on a table and look down. Use a microscope and magnifying glasses to open up a new world.
- Enjoy each other's art projects. Display the children's artwork regularly and attractively. If they are old enough, let them make the display. (Before making any comments on the art, read Chapter 7 on Evaluation.)
- View famous art by visiting museums and art exhibits. This can also be done through art appreciation books from the library, such as *The Story of Painting for Young People* (83), *The Meaning and Wonder of Art* (78), *Going for a Walk with a Line* (95), or *Wonder under*

Your Feet (99). There are many others available. (These books are not for preschoolers but for older children.)

- Provide many opportunities for the selection of colors, materials, pictures for displays, gifts, and so on. In the selection of home furnishings and clothing, parents have many opportunities to expand the child's visual awareness.

ARRANGING

Arranging things is a follow-through aspect of seeing and selecting. Allow children responsibility in the following areas:

- Arranging personal things in an orderly way.
- Arranging school room and supplies.

 With older children, it is great fun occasionally to give them a day when they can rearrange the furniture in the room any way they want to for that day. Many learning experiences develop if you step out of the room and give them a time limit.

- Table or shelf display and bulletin boards.
- Decorating of cakes and cookies.
- Holiday and party decorating.
- Displaying flowers and other natural forms.

 Let the children arrange frequently changed displays, such as seashore objects, wood objects, weeds, rocks, miscellaneous nature objects, such as birds' nests, gourds, unusual fruits and vegetables. They can choose white, black, or colored background paper to best accent the color, form, and texture of the things displayed.

- Bean layering. Dried beans come in many shapes and colors.

 Provide the child with a large jar with lid and a variety of beans (dried lentils, kidney beans, black-eyed peas, split peas, and so on). Encourage the arranging of the beans in layers to make an attractive room decoration.

- Pocket art, for older children.

 Use hinged picture or card holders that go into billfolds, and let the children make their own walking art displays of "found art." Each holder can be a design itself, or the whole packet can be a collection of items that have eye appeal to the child (tickets, labels, wrappers, feathers, leaves, magazine pictures).

- Use commercial toys that encourage an awareness of arrangement, such as blocks to teach form and balance, colorforms in geometric shapes, play tiles, small wooden parquet blocks, magnetic forms in basic shapes, kaleidoscopes and teleidoscopes, felt boards with geometric felt pieces.

Collage is a rewarding type of arranging that will be discussed in Chapter 13. In fact, most of the art activities in the next chapters consist of arranging the elements of art, although the child would need the help of the adult to become aware of this.

> *Though we travel the whole world over to find the beautiful,*
> *we must carry it with us or we find it not.*
> RALPH WALDO EMERSON

Art is essentially a quest for order. (16)
COHEN AND GAINER

13

pasting and assembling

MOST of this chapter deals with collage, which comes from the French word *coller*, meaning to glue or paste. Other methods of assembling use tape, staples, gummed paper, and dough. We generally think of a collage as a collection of textures on paper or another flat surface. The emphasis in this chapter is on two-dimensional assemblages (three dimensional are discussed in Chapter 19).

Why do collage? Because

Few stereotypes exist to show how collage should look; hence, children are freed from clichés and may be more inventive.

It imposes a sense of order on random materials.

Making a collage is an exercise in building something out of scraps.

The tactile nature of the activity makes it fascinating (to all ages).

It is a good idea to explain to children that "We are going to make a 'feeling' picture, a design that we can actually enjoy with our hands as well as our eyes. It is more exciting to make

something that can be both felt and seen instead of just seen." One might begin by having the child handle the materials with eyes closed and tell how they feel (soft, smooth, rough, and so on).

Found Object Collages

In the preceding chapter, the child was looking and collecting. Now the collected items can be used in a collage. Children can enjoy arranging the weeds, leaves, pebbles, feathers, seeds, or whatever on a firm base and, with a bit of white glue, make a found object collage. The inside of the top of an egg carton makes a nice background to paste on. It can be used "as is" or painted beforehand. Put a string through the holes of the egg carton and it can be hung.

Collage Backgrounds

Styrofoam trays used for meat and bakery goods
Shirt cardboards and poster cardboards
Sides of cardboard cartons (can be painted the day before)
Wood (including shingles and driftwood)
Plastic lids from coffee cans and margarine tubs
Corkboard and chipboard
Egg carton lids
Burlap, vinyl

COLLAGE ADHESIVES

White glue This is probably the most popular adhesive for collage work. It can be thinned down with water and brushed on when doing tissue paper collage or decoupage-type work.

Collage dough (Made with half flour, half salt, water to mix) This can be spread thickly in the top of an egg carton or styrofoam tray, and objects such as shells, pebbles and so on can be laid in it. This same dough can be used to make collage pieces adhere to paper and other surfaces.

Plaster of paris Put mixed plaster of paris, available from hardware stores, into a shallow plastic container or box lid and *quickly* arrange pine cones, twigs, nuts, and the like on the surface. Food coloring can be added when mixing the plaster. It will set up in about 15 minutes. NEVER put leftover plaster down the drain, as it will clog the pipes.

Collage Paste

Uncooked paste To a handful of flour or dry wheat paste (from the hardware store) add water, a little at a time, until the mixture is creamy and thick. This is not as sticky as boiled paste, but it will hold scraps of paper together. Or it will afford the child the pleasure of just smearing it. (The shy child will play with paste before attempting fingerpainting.) Store the paste in a covered container. A few drops of oil of peppermint or wintergreen can be added as a preservative.

Boiled paste Mix ½ cup of nonself-rising wheat flour with cold water until it is as thick as cream. Boil gently for about 5 minutes, stirring constantly. If it needs a little thinning, add cold water. A few drops of oil of peppermint, cloves, or wintergreen can be added as a preservative, if the paste is not to be used the same day it is made. Store in the refrigerator in an airtight jar. This keeps longer and sticks better than uncooked paste.

Soap flakes Beaten soap flakes can be used to adhere lightweight things when keeping the collage is not important. Use about ¾ cup of soap flakes to 1 tablespoon of warm water and beat with an electric beater.

Pasting pointers Use old magazines for paste-applying surfaces. When a clean surface is needed, just turn the page. For preschoolers, fingers are the best paste applicators and offer the most sensory experience. Children who are reluctant to get dirty can use a Q-tip, brush, tongue depressor, or small cardboard with a straight edge. Keep a damp sponge or cloth nearby for cleaning fingers.

COLLAGE MATERIALS

Nature: Anything having to do with nature—pieces of wood, twigs, grass, seeds, feathers, dirt, sand, leaves, cones, bark, pods, shells, pebbles, crushed rock.

Older children should get some idea of a design or pattern before starting. Have them notice contrasting effects—dull-shiny, vaulted-flat, and such.

Assorted Materials: Sometimes offer a tremendous variety of materials, such as fluffy cotton or cotton balls, dry puffed cereals, toothpicks, straws, popsicle sticks, macaroni (dyed or plain), clock parts, broken jewelry, buttons, bottle caps, corks, pipe cleaners, dried beans, old film, wire, fur bits, cupcake cups, yarns, steel wool, egg shells, assorted papers, and so on.

For all ages, use safe materials.

Have a treasure box or scavenger box where such items are deposited.

To dye macaroni, use 1/4 cup rubbing alcohol and a lot of food coloring in a pint jar. Add macaroni and shake until the right color. Dry immediately in sieve.

Tissue Paper: Use a variety of colors, cut or tear pieces. Brush diluted white glue or liquid starch on heavy paper and lay it on torn tissue. Add an extra coat of glue over the paper to obtain a glossy surface. The child can later use crayon, felt pen, or paint to add details.

Begin with lighter colors to create new colors by overlapping.

Child can look for hints of faces, animals, or figures and build on those.

Good sensory experience.

The very young especially enjoy smearing a few drops of baby oil on wax paper and then pressing down torn tissue pieces. For a second layer, add a few drops more of oil.

Product is nonpermanent.

Assorted Paper: Include foils, paper towels, colored cellophane, gift wrapping paper, sandpaper, newspaper, magazine pages, wallpaper, old greeting cards, paper doilies, corrugated cardboard, tissue paper, velours, candy and gum wrappers, old phone book pages.

There are more than 7,000 different kinds of paper. Collecting papers can be an awareness project in itself. Encourage children to study the variations in texture and color. Encourage observation of how colors show up against the background color.

Practice tearing first. Allow the child to paste each shape as it is produced. Cutting them all and then arranging is more suitable for older children.

See next chapter for tearing ideas.

Variations:—The child can cut up his or her paintings, or—crayon rubbings can be cut up and assembled into a collage design.

Encourage the use of small, medium size, and large pieces, as this will make the design more interesting.

Geometric Shapes: The child designs with pieces of paper cut in standard geometric shapes. These can be all of one shape in many sizes or a variety of shapes.

See Chapter 15 on crayon rubbings.

Use precut shapes for younger children.

Variations:—Use gummed-back sheets of paper.
—Cut out circles from brightly colored ads in old magazines. Cut some in halves and quarters. Make designs, animal pictures, and so on.

Eliminates glue. Add paper reinforcers, gummed labels, and such. Use coins for patterns.

Fabrics: Keep a box of clean, neatly cut cloth scraps available. They should vary in color, pattern, weave, and texture. Add pieces of trimmings, ribbon, fringe. Mosaic-type pictures can be made with bits of cloth.

A large piece of fabric can make an interesting background.

Materials to be cut by children need to be light in weight.

Sprinkle Art: Make a design or picture outline with glue or paste on construction paper. Immediately sprinkle the glue with soap powder, sand, salt, sugar, colored sawdust, or colored rice. Scraps of colored paper or crayon or paint can be used to complete the picture.

For colored sawdust or rice, pour it into diluted tempera and then allow to dry.

Pebble Picture: Glue small stones on a piece of cardboard and draw or paint in the rest of the picture.

The pebbles may become eyes, flower centers, animal bodies, and so on. Three-dimensional rock creatures are discussed in Chapter 19.

Yarn on Sandpaper: Create designs or "draw" shapes with yarn on sandpaper. It will readily adhere to coarse sandpaper.

This is great for the very young. If the picture does not please, the child can easily redo it. It is economical because the materials can be used over and over.

String Designs: String, yarn, rope of various kinds are used to form a design on a glue-spread surface such as cardboard or a shingle.

Older children can be encouraged to fray, braid, knot, twist, and coil the material. This can be a discovery project in itself before collage making.

Wax Paper Designs: Press between two layers of waxed paper or between waxed paper and plastic wrap, such things as leaves, crayon shavings, pieces of colored tissue paper, or yarn scraps.

For a pressing surface, a table top can be padded with newspapers and an old sheet or bath towel. Use the iron on dry warm setting, and use either a pressing cloth or newspaper on top of the wax paper.

Crayon Mosaics: Cut crayons in 1/4-inch lengths and glue them on cardboard. A design can be drawn before gluing the crayon rounds.

This is a great use for worn and broken crayons that would otherwise be discarded.

Paper Mosaics: Precut pieces of paper about 1 inch square are used to make a design or picture. A little space is left between each piece. The outline of the design is drawn first.

A good project for older children. Black paper is the most effective background. White chalk can be used for the outline and rubbed out later with facial tissue.

Three-dimensional assembling is described in the chapter on Constructing.

14

tearing, cutting, and folding

WE generally think of tearing and cutting as preceding the pasting and assembling described in Chapter 13, but small children usually can paste and assemble before they can tear and cut.

PAPER TEARING

For 3-year-olds, scissors are frustrating, but they enjoy tearing paper. All children will get more satisfaction from tearing paper until they are able fully to control the scissors. It is a marvelous activity for releasing pent-up energies, especially those coming from inhibitions or built-up anger. It also develops visual motor perception, increases the ability to control finger muscles, and enlarges the child's awareness of shapes, sizes, and proportions.

TEARING TECHNIQUES

Provide old magazines, phone book pages, or tissue paper and let the children tear out pieces of paper to their hearts' content. For the inexperienced child, tear the pages out of the magazine so they will be easier to handle.

Practice tearing paper together. Talk about their "pinching" fingers. "Keep both pinchers together to get the paper to do what you want it to do." Children can learn to control the torn edge by moving their fingers inch by inch as they tear. (The direction of a long tear cannot be controlled.)

These can be pasted overlapping on cardboard, paper plates, or construction paper. Older children can let the shapes determine the subject and complete the picture with crayons. They can tear a dress and draw a girl, or tear an animal and add eyes, for instance.

"Let's tear a small piece from our big piece." "Let's tear our paper right in half." Tear, together, long skinny strips, tiny bits, and so on.

PAPER CUTTING

This activity offers exercise in developing dexterity and muscular control. Children need lots of practice and experimentation. They might begin by all pretending to cut the air in tiny pieces. Try cutting a piece of cloth with your left hand to feel how difficult it is for preschoolers to learn to handle scissors and how difficult it is for left-handed children to use right-handed scissors. "Lefty" scissors are available for those wishing them, but some art teachers feel that they are an unnecessary crutch. Younger children should be provided with good quality 5-inch, blunt-nosed scissors. (Remember that very thin paper is difficult to cut.)

The following are cutting exercises:

- Cut along a coiled line on a very thin paper plate.
- Provide a collection of old greeting cards that children can cut in any way they wish.

- Cut along lines or around pictures that children have drawn themselves. This provides more incentive than adult drawings.
- Children enjoy cutting clay into pieces, so try scissors at the clay table.

Cutting along a coiled line on a paper plate is a good scissors exercise.

What to Do with Torn or Cut Paper

As indicated in the preceding chapter, torn tissue can be put on wax paper with oil or pressed between sheets of wax paper or plastic wrap. Cut construction paper can be used in collages and mobiles. Have a stapler and tapes of various types available. For mobiles, paste two or three of the shapes together, punch a hole near the top and hang by string from a line stretched across the room. Or they can be hung by string from coat hangers.

Cut or torn paper mobile.

PAPER TECHNIQUES

Treat the surface of the paper to add texture. Practice scoring and bending the paper, curling and twisting it, perforating it. (Make holes with a punch or pointed object.) Crush paper in the hands to produce wrinkles.

Paper folding can include everything from complicated origami animals to newspaper hats. Encourage children to make their own creations with the aid of tape and staples (party baskets, hats, doll furniture, and so on).

Fold paper several times: with scissors, cut straight and curved lines, unfold the paper, and bend the cut tabs upward. These shapes can be hung by yarn from coat hangers to make mobiles.

Origami is useful for learning to follow directions but does not contribute to creativity as a rule.

Warning: Do not expect more than the child can do.

Great books with specific ideas and directions are available in libraries, for example:

Paper Construction for Children by Krinsky and Berry,
New Dimensions in Paper Craft by Sadami Yamada,
Creating with Paper by Pauline Johnson,
Creative Paper Design by Ernst Rottger, and
How To Be Creative with Paper by J. M. Parramon.

*"Remember, the good drawing is one
in which the child puts something of himself.
It is an honest original idea
of his own." (82)*
HOOVER

15

drawing and rubbing

PICASSO has said that we, as adults, should not teach children to draw, but should learn from them. This admonition applies not only in this chapter, but throughout the book.

The child has an inborn need to draw. It is a mode of expression and valid in its own right. For some children it is a tremendous release, since they can express more about what they are thinking with crayons than with words. Scribbling is considered the most important of early art experiences.

It is good to provide as wide a variety as possible of drawing implements and surfaces.

DRAWING TOOLS
(instruments to mark surfaces)

Fingers	Felt-tip pens	Oil pastels
Crayons	Ball Point pens	Nails
Pencils	Soap	Toothpicks
Chalk	Sticks	Straws
Charcoal		

SURFACES ON WHICH TO DRAW OR PAINT
(encourage experimentation)

Paper:	Other:
Newsprint	Wood
Paper plates	Cloth
Corrugated paper	Acetate
Sandpaper	Cardboard (corrugated,
Wax paper	pressed)
Paper bags	Chalkboards
Wallpaper samples	Plastic wrap
Paper towels	Aluminum foil
Crepe paper	Plastic (table tops)
Butcher paper	Packed soil, clay
Carbon paper	Sand
Wrapping paper	Steamed mirrors
Shelf paper	Fogged windows
Paper doilies	Waxed windows
Tracing paper	
Graph paper	

To stimulate the child's imagination, vary the size and shape and the paper. Go so far as to cut it into irregular free form shapes and/or draw on it a geometric shape that the child is challenged to incorporate into a drawing. Clare Cherry (68) calls this kind of paper "imagination paper" and has many illustrations of the kind she offers to children. She says to make no special comments about the paper size, shape, or markings, but just let the child cope with the special challenge it has for his or her imagination.

CRAYONS

Crayons aid in small muscle development. But there is an objection that, for very young children, they encourage too much use of the smaller hand and finger movements. These children need to use materials that are in keeping with their muscular development and that will teach control of the larger body movements.

For preschoolers, the crayons should be the largest size and soft enough to produce color with a minimum of pressure. Peeling them and even breaking them is suggested.

Peeled crayons can be used on their side to produce a variety of creative effects. Some school districts buy crayons without wrappers at a cost saving.

Breaking the crayons can release the child from the tension and fear of "What will happen if I break this?." Encourage the use of the crayon on its side, tip, and bottom, using light and hard pressure in all positions. Try using two tied together. Experiment to see how colored paper changes the color of the crayon. The range of colors is doubled when used on colored paper. With 2- and 3-year-olds, play a color matching game with the crayons. For the very young child, dark color crayons are more satisfactory, as they are softer and offer more contrast to light paper. Children are more pleased with the results when they have pressed hard with the crayons, so encourage them to use pressure. For variety, take the crayons and paper outside and use them on the sidewalk. Or put a pad of newspaper underneath to give crayon drawings a softer effect.

Older children can be given a piece of white chalk to use with their crayons. For pale tones, they use the chalk as a base

and rub crayon on top of the chalk. White chalk with orange crayon makes a good skin color. Encourage the mixing of crayon colors. Completed wax crayon pictures may be given a glossy sheen by rubbing over them with a soft cloth.

If crayon marks show up where they do not belong, these suggestions may prove helpful:

Ordinary machine oil will often remove them from a table.

An eraser will remove crayon from a terrazzo floor.

Try rubbing lightly with baking soda sprinkled on a damp cloth when crayon is on varnished wood and floors.

A strong solution of ammonia and hot water, applied with a soft towel, will usually take crayon off painted walls.

Toothpaste will often remove crayon marks.

A box of baking soda added to the laundry is usually effective when crayon has been left in a pocket.

Other Crayon Uses

Crayon etchings (also called scratch drawings): The child covers the paper with a thick layer of light crayon, then covers this with a dark crayon or ink. The picture is made by etching through the top layer with a pointed tool or by scraping broad outlines. Orange wood sticks or popsicle sticks can be used.

For a simpler version, cover the paper solidly with crayon, and use a finger nail to scratch the picture.

Crayon shaving designs: The child uses a crayon sharpener, vegetable grater, or dull knife (can also pound broken crayons into bits). The shavings are sprinkled in a design on paper. This is covered with newsprint and a warm iron is run over it.

It makes marbleized paper.

Child can add more to the picture by drawing or scratching lines into the colors.

For variations, put the shavings between two layers of wax paper and then between newspapers to iron (can also be done on fabric—see below).

Crayoning on fabrics: After the child has colored his design or picture on the fabric, cover it with either a damp cloth or wax paper covered with newspaper and press with a warm iron to set the design. Or place fabric face down on clean paper and iron. Washing in warm suds helps to set the colors.

Do some with tissue paper for gift wrap.

Safety tip—have the child put one hand behind back when ironing.

Try this out on old sheets and painting shirts. Great for place mats, school smocks, team T shirts.

Crayoning on fabric makes a
nice variation.

Paper plates: After crayoning paper plates, put them in a warm oven for a few minutes to set the color. Add a gummed-back picture hanger on the back, and it is ready to hang.

Can be used as servers for popcorn or crackers at snack time.

Pull tabs from soda pop cans can also be taped on the back for hangers.

Crayon melt: Child places piece of paper on an electric food-warming tray set on medium and uses large size crayons on their side. They will quickly melt producing interesting smears and blotches. Child can draw directly on foil and then press down paper and "pull a print." Before making a new design, wipe off the excess wax with a paper towel.

Cover tray with smooth heavy aluminum foil first.

The hand that holds the paper should be protected with a hot mitt, rag, or sponge.

Turpentine trick: As oil crayons are soluble in turpentine, interesting effects can be obtained by using a brush or rag dipped in turpentine to blur the crayon strokes.

Or draw with oil crayons on paper that has been dampened with turpentine.

Crayon resist: Child paints over his crayon drawing with a thin wash of either tempera, ink, food coloring, or water color. Where there is no crayon, the paper will be stained leaving an interesting effect. Drawing on black construction paper and covering with diluted white tempera is interesting.

Based on principle that wax will repel water paints.
Variation: Design is brushed or dribbled on with rubber cement. After wash is dried, the cement is rubbed off.

Crayon rubbings: The rubbing is made by placing light to medium weight paper over a textured surface and then rubbing with the side of a crayon to reveal the pattern beneath. Collect a variety of surfaces that can be used under the paper. These are easier to work with if stapled or glued to cardboard.

Older children can make rubbings of different textures found around the house, yard, and school. Finding the "works of art" to be rubbed can be lots of fun. Tape may be used to secure the paper to the surface being copied.

Sometimes called "second-hand" art. Lightweight paper makes the strongest impressions.

Possibilities for beginning rubbings are:
Coins, glued to cardboard
Chicken wire
Corrugated paper
Wire mesh (hardware cloth)
Embossed floor tile
Bamboo curtaining
Heavily textured fabric
 (lace, upholstery)
Nature items (leaves,
 ferns, tree bark, shells,
 feathers)

A picture can be composed of these rubbings as they are collected, or the rubbings can be cut into shapes and glued onto a large paper to create a picture.

Rubbing/resist combination: Use a colorless white candle on white paper to make the rubbing. A wash of color is painted over it, leaving a white rubbing against a tinted background.

Three children's books with rubbing ideas and examples are *Full of Wonder* by Kirn (89), Ota's *Printing for Fun* (100), *Simple Printing Methods* by Cross (71).

CHALK

Chalk is a satisfying medium to use as it is colorful, glides easily over the paper, and can be blended by rubbing. Since it will rub off on hands and clothes, it is a good idea to wrap one end of the chalk with masking tape and provide aprons or old shirts to be worn by small children. For preschoolers, provide the 1 inch diameter soft chalk in vibrant colors. Encourage the child to experiment with dry chalk and become familiar with it before going on to wet chalk. Suggest using the chalk on its side. The chalk picture can be sprayed with a commercial fixative or with hair spray. Consider using individual slates or chalkboards. There is an aerosol available that dries quickly to form a ready-to-use chalkboard surface. It can be sprayed on metal, wood, plastic, glass, paperboard, or old chalkboard.

Wet chalk When used wet or on a wet surface, the chalk will dissolve, becoming richer in color and more fluid. The wetting agent acts as a fixative so that the color is not as easily rubbed off.

Wet paper–dry chalk Nonabsorbent paper may be brushed or sponged with water to which a small amount of sugar has been added. For variety, wet paper towels can be used as drawing paper. Add 1 part sugar to 4 parts warm water. This is as satisfactory as milk solutions and more easily available.

Dry paper–wet chalk The paper can be used dry, with the chalk dipped in the above wetting solution before drawing. This saves the extra step of wetting the paper, and the child sees immediate results. Wetting the chalk makes it unsatisfactory for dry use again, so keep it separated from the rest.

ADDITIONAL DRAWING IDEAS

Free drawing is best of all, but sometimes children, as they get older, require a new approach to stimulate the imagination. Then is the time to suggest various activities. (Many of these could be called "think drawings" because the emphasis is on creative thinking and not on the quality of the drawing.)

Self pictures An adult or another child draws an outline around the child on a large piece of paper. Let the child then color or paint in a self picture. Or encourage the child to draw his or her own outline after first closing the eyes and feeling the body (fun for parties and birthdays).

Self-portraits build the self-image.

Carbon paper drawing Place carbon paper between two sheets of lightweight paper and clip together. The child draws with a pencil and lifts the paper to see the identical impression underneath.

Old shape—new use The child traces the shape of a common object—the bottom of a shoe, a pair of scissors, a hand, a paint brush. Then, using crayons or felt pens, the shape is turned into something else. The child should ponder what the shape could become and get several ideas in mind before deciding on the one to draw. This is an especially effective activity when all the children use the same object, because their imaginations are stimulated by seeing the array of ideas.

Window drawing Rub glass wax all over the window and allow it to dry. Invite the children to draw with their fingers. When finished, they can clean the window with a cloth.

Expressive lines Youngsters make a series of lines on paper—all showing some quality of action or emotion. Suggest happy lines, sad lines, lines that skip, jump, dance, explode, and so on.

This activity can be stimulated by some lines from the fun book *What's in A Line.* Author Leonard Kessler (88) says

*"You can make thick lines
or thin lines, dotted lines
or blotted lines,
Lines going up and lines coming down*

*Hot jagged lines, or
Lines that are cool.*

*Lines that go splash
right into a pool.*

*Your line can make a square
Or your line can make a round.*

*Your line can be fast
Or slow like a caterpillar
down on the ground*

*A line can move like you on a swing
A line can be most anything."*

He concludes by saying, "A line is only an idea, caught and set down in little marks," and asks, "What's your idea?"

Fingerprint figures Using an ink pad, such as is used with rubber stamps, the child puts several fingerprints on a sheet of paper. With imagination and a pencil or felt pen, these are turned into animals, people, or what have you. Emberley's *Great Thumbprint Drawing Book* (73) is full of excellent examples, and so is *Fingerprint Owls and Other Fantasies* (86a).

Music drawing Have children sit in relaxed positions with their eyes closed. Tell them they are going to visit a favorite place where they can have lots of fun. Ask them to see on the "movie screen" inside their heads pictures of themselves engaged in a favorite activity. Then put on some music and ask them to see pictures in their heads suggested by the music. They may have lots of pictures, which means they can just sit back and watch the movie. After a few minutes, stop the music and ask them to draw one thing they saw.

Pebble picture A handful of pebbles is dropped on paper and a dot is put wherever a pebble lands. A picture is drawn that includes all the dots.

Beginning a pebble picture.

Scribble picture The empty spaces of a random scribble are colored in, or animal shapes are discerned within the scribble and features added to make them recognizable.

Doodles and initials The child draws one or several and then incorporates them into a picture. Circles, squares, triangles, and wiggly lines can also be used as the basis for a picture. An adult could draw several circles widely spaced on a large sheet of paper and have the child incorporate each into a different drawing. Then the same thing could be done with a zigzag line, and so on. These are real imagination stretchers.

Unseen drawing The child looks only at the subject model, not at the paper. Dr. Edwards (6c) suggests drawing the contour of one's hand while facing away from the paper to prevent any peeking. Habits of seeing interfere with and block the ability to draw, she says. This technique gets the right brain involved, which is the appropriate hemisphere for the task of drawing. A variation is to have the child hold a fruit, vegetable, or other simple shape and draw it with his or her eyes closed.

Upside-down drawing Placing a picture or object to be drawn upside down confuses the left brain, according to the research of Dr. Edwards (6c). This leaves the task to the right brain, which finds drawing easy and enjoyable.

Inner-view drawing The child looks at an object briefly and then turns away to draw it from memory.

Sketch books Many artists and art teachers feel that a child should start early to carry a sketchbook to record not only what he or she sees, but feels as well.

Remember always that children should be encouraged to draw things in their own way, as they see and understand them. They will be cheated of the opportunity to think creatively if you show them "how" to draw. One way to "free up" their drawings is to allow them to draw in space with a flashlight, as did Picasso.

A crayon in the hand of a child
is a key that unlocks thoughts and concepts
of the world in which he lives. (93)
LALIBERTE AND MOGELON

"Learning to draw is really a matter
of learning to see—to see correctly—
and that means a good deal more
than merely looking with the eye. (99a)
KIMON NICOLAIDES

They paint what
they experience
They experience what
they paint.
KENNETH JAMESON

painting

EACH child is an individual and responds to life in his or her own way—and so paints individually too. Painting is of special value to the child as a form of relaxation, of communication, and as a means of emotional release. (Other values are listed in Chapter Three.)

Painting Tools

For painting tools, the following can be used:

Hands, feet.

Brushes of all kinds—paste, tooth, bottle, paint.

Sticks, branches.

Blocks of wood.

Rope, string.

Rags tied to a stick.

Sponges (held by clothespin).

Toothpicks, Q-tips.

Dish scrapers.

Roll-on deodorant bottles.

Shoe polish applicators.

Feathers. Plastic squeeze bottles.
Cotton balls. Pipe cleaners.
Rollers. Drinking straws.
Rags. Feather dusters.

Some persons feel that for the school-age child, conventional tools (pencils, crayons, brushes) are more difficult to use with flexibility, fluency, or inventiveness. They need tools that are stimulating. Combining different tools can offer an almost endless number of experiences. Tools should be chosen according to the feeling one wants in the picture.

Painting Surfaces

Surfaces to paint on are listed in Chapter 15, but here, for ready reference, are some of the most popular:

Newsprint	Plastic table tops
Butcher paper	Wallpaper samples
Wrapping paper	Newspaper classified pages
Cardboard	Wood
Paper plates	Cloth
Paper bags	Windows
Corrugated paper	Paper doilies
Shelf paper	Acetate transparencies

Encourage experimentation to find out how surfaces and tools interact with each other. This helps build awareness. Include some object painting (rocks, small boxes, wood blocks, cartons).

Painting Liquids

For painting liquids, use the following:

Water colors.	Liquid shoe polish.
Food dyes.	Muddy water.
Tempera paints.	India ink.
Bleach.	Tea, coffee.
Liquid wax.	Berry juices.
Glue.	Whipped soap flakes (recipe under handpainting later in this chapter)
Rubber cement.	

Paint Mixing Tips

- Glass jars with tight lids are preferred as evaporation causes the paint to thicken.
- Use powder tempera paint and mix in an almost equal amount of water or liquid starch. The starch helps to make the paint thicker, keep better, go on more smoothly, and adhere better. A little dry wheat paste will do the same. Add 1 tablespoon of dry wheat paste to ½ pint of powdered paint.
- Whether using water or starch or some of both, the paint should be the consistency of thick cream—thick enough that one cannot see the paper through it, and if painted on a vertical surface it

does not run down, but thin enough to flow easily. If it is too thin, it is difficult to control and lacks brilliance.

- When mixing, never add tempera to water. A good method is to put a pint can of powder paint in a quart jar and fill the jar with liquid starch. Screw lid securely and shake well. When it is time to paint, put some of this mixture in a small jar and thin it with water. Keep filling the quart jar with starch. Add soap to the mixture (liquid, chips, flakes, sink cleaner) if you want the paint to adhere to glossy metal, wax cartons or cups, cellophane or foil.

- To prevent a sour smell in powder paint, add a little oil of wintergreen, cloves, or peppermint.

- Powder paint can be made glossy by mixing in a little evaporated milk or glycerine.

- Red, orange, and violet are difficult pigments to mix with water. A few drops of alcohol will speed the mixing.

- To mix a pastel color, start with white powder and gradually add the color to it until the desired tint is reached. Then add liquid.

- To keep colors clean, encourage using one brush for each color. If a child wants to mix colors, suggest finger painting or set up for him or her in another area (great way to use leftover paints).

- When painting rocks, add about 2 tablespoons of Elmer's Glue to a small jar of paint and starch mixture. This will make the paint adhere, brighten the colors, and give a little gloss.

- Keep jars not more than one-third full because of unavoidable spills.

- The smaller the child, the thicker the paint should be.

- Colors—only three or four for the younger child, and the full range by age 5. Include at times both vivid colors and pastels as well as black, brown, and gray.

Brushes

Supply both round and flat stiff-bristled brushes, the round ones about 1 inch long and ½ inch wide, the flat ones, about 1 inch wide, with a few narrower ones for special projects. There should be a brush for each color and some extras in case a child wants to experiment with mixing colors.

Cheap brushes wear out more quickly, so they provide no saving in the long run. Reshape old brushes by cutting off the tips with a razor. Teach respect for tools and have the brushes washed right after use. Cleaning up can be a basic part of the activity. Avoid washing brushes in hot water, which might dissolve the glue in which the bristles are set. Store brushes with bristle end up or wrapped in newspaper. Use different kinds of brushes as the year goes on (feathers, and so on, from above list).

When paint is first introduced, the child needs to be shown how to wipe the brush on the inside of the jar to remove excess paint.

Working Surfaces

- Double easels with shelf to hold paint jars. Do not place easels side by side (too much temptation to copy).
- Table (cut down card table, works well for little ones) or big flat box. To hold paint jars, cut holes in milk cartons and set in small jars or orange juice cans. Pop bottle cartons work well also to hold paint containers.
- Wallboard set up against a wall.

A tabletop easel can be made from a cardboard carton. Two children can use this, one on each side.

- Cardboard carton cut at an angle so that ends form triangles, makes a table easel. Make slits at the top, and use clamps or clothespins to hold the paper.
- Floor—protect with newspapers or plastic drop cloth.
- Sidewalk, driveway, carport.
- Mural paper on the wall or floor, for older children.
- Slab of glass on the floor, great for foot painting.

Clothing protection The very simplest painting smocks are men's shirts with the sleeves cut off and buttoned down the back, or rectangles of oilcloth with a hole in the middle to slip over the head. It is best to have the child wear worry-free clothing. Worries about cleanliness at this age can be too distracting from the process.

Music as an accompaniment Try integrating art with music for a stimulating experience. The record player can provide good background music—"music to paint by." Or as a child paints, notice a particular rhythm and make up a song or chant to go with it. Children might listen to a classical selection with their eyes closed until a strong mental picture comes to mind. Then they proceed to paint. Dance music encourages lots of rhythm in painting.

Suggestions Paintings that get curled or warped when dry can be pressed flat with a warm iron. This also applies to hand or finger painting.

Always write the child's name and the date on the picture. It is also nice to include the child's comments about the work or his or her title. This is especially helpful when paintings are taken home from school, as it prevents the parents from voicing wrong conclusions. When the child's description is written on the work, it helps to link concepts in the child's mind. He or she begins to grasp the relationship between the object, the spoken word, and the written word.

You may wish to mount the paintings on black or colored paper and display at eye level. Cole (6b) suggests trimming weak edges or one side of the painting if it is too much off balance. She feels this trimming and mounting helps the picture and, therefore, boosts the child's self-confidence.

Painting Variations

Water painting Some teachers introduce painting by having the children "paint" on the chalkboard or table with water. This gives an opportunity to practice swirls, lines, dabs, twists, meanders, and zigzags. Very young children enjoy painting fences, sidewalks, and the sides of buildings with a large brush and a bucket of water.

Window painting Window cleaners (such as Glass Wax or Bon Ami) may be colored with dry paint powder and used to paint windows.

Spot painting Sometimes called blot or blob painting, this is a form of printing. With a small spoon, the child puts a blob of paint on the inside of a piece of folded paper. The paper is pressed together, then opened to see the results. It is fun for children to use their imaginations and "see" things in the pictures. Similar to double designing under handpainting.

Strawpainting (also teaches science). With finger over the top of a straw, pick up paint and drop it on paper. Then blow *gently* through the straw to spread the paint. Use a separate straw for each color.

Straw painting.

String painting White wrapping string, about 12 inches long, is dipped in a shallow container of paint. Holding the dry end, the child drags, swirls, or plops the string on a piece of paper. A variation is to lay the dipped string on half the paper and fold it over to make a double-image picture. While the paper is folded, and held down with one hand, the string can be pulled out.

Sponge painting If the child learns to pat, not rub, with the sponge, a very interesting texture results, especially if a natural sponge is used. This is also a form of printing but makes very lovely paintings. There should be a separate sponge for each color, if it is being dipped in paint. Or paint may be applied to the sponge with a brush. The sponge can be held in the hand or by a spring-type clothespin. It is a good use for old sponges.

Bleach painting Brush undiluted bleach on colored construction paper or diluted bleach on fabric. Bright colored cotton (nonsynthetic) is best. Rinse the fabric right away to limit the bleaching action. Be sure to protect clothing. This activity is not recommended for pre-schoolers.

Detergent painting Mix liquid detergent with powdered poster paint. Use on glass, aluminum foil, glazed paper.

Fold and dip Rice paper or two- or three-ply facial tissue is folded several times and dipped into undiluted food coloring (in muffin tin cups). Typing paper or paper towels can also be used. An effective way is to accordian-fold the paper lengthwise, then fold the strip back and forth to make triangles. Dip each corner into color. When the paper is unfolded, the design is revealed.

Resist painting As explained in Chapter 15, the child creates a design or a scene with crayons or rubber cement, then paints over the entire paper with a thin wash of water color, tempera, or food coloring. The crayon or rubber cement resists the paint to provide an interesting effect. Rub off the cement when the paint is dry.

Chalk painting Wet chalk can be used on dry paper or dry chalk on wet paper to make vivid paintings. (See Chalk section in Chapter 15 for details.)

Object painting Objects include large cartons for hide-aways and puppet theaters, gift boxes, rocks, pine cones, totem poles, egg cartons, macaroni for necklaces.

Foot painting Mix paint in a shallow baking dish. Let children dip their feet in and paint on large sheets of butcher paper. Or they may paint with their feet on glass and "pull prints." This is best done outdoors, but if indoors, spread a sheet of plastic or oil-cloth on the floor. A variation is to have them paint their own feet with a brush. Be sure to have a dishpan of warm soapy water and some towels at hand.

HANDPAINTING
(Fingerpainting)

Fingerpainting has been misnamed and will be referred to here as handpainting, since its aim is to encourage hand movements rather than finger drawing. It is considered more of a motor activity than a picture-producing art form and is usually introduced to the child before brush painting. The advantages of handpainting to the child are that

- It is a marvelous sensory experience and offers the smearing activity that many children need.
- It has a calming effect on children who are keyed up and tense.
- It provides opportunities for big rhythmic movements of the hands and arms. (Standing is recommended because it affords greater freedom of arm movement.)
- It is a great way to learn about color. Offer the primary colors and have the children blend these to produce new colors.
- Last, but not least, it's *Fun!*

Handpainting.

Surfaces to Paint On

Slick butcher paper, waxed paper, or shelf paper

Formica tabletop

Scrap linoleum

White oilcloth

Cookie sheet

Bathtub

Old wallpaper book

Windows

Avoid absorbent paper.
(Need a glaze on the paper.)

A cut down card table covered with oilcloth makes a permanent fingerpainting table.

What to Paint With (Recipes)

Only noncook recipes are offered here, since the children can help in their preparation and they are a lot easier for most adults.

1. Liquid starch. Simply pour it on the paper and shake on powder paint. The starch can be smoothed over the paper and played with before adding paint or it can be used alone on dark paper.

 Simplest method—if paint is put in a shaker can, the child can add it him- or herself.

 Starch is unsafe if child still puts things in his or her mouth.

2. Wheat paste. If you are out of starch, put a cup of water into a bowl, then add wheat paste slowly, stirring constantly until it is the consistency of whipped cream.

 Also called wallpaper paste, available at the hardware store and inexpensive. The whole batch can be colored with poster paint or each glob can be colored separately.

3. Soap powder. Mix soap powder with a little water into a smooth paste and add dry paint powder. Whip until stiff, if desired.

 Variation. Mix, in large bowl, 2 cups instant soap flakes and ½ cup water.

 Let the children help beat it. Try a large ball on black paper or foil, or use colored construction paper.

4. Cold water starch. Mix a 12-ounce box of cold water starch with an equal amount of soap flakes and slowly add 2 cups cold water. Beat until consistency of whipped potatoes. Add paint.

 Makes 1½ quarts.

 Dark colors show up more effectively or can be used as is.

5. Shaving soap. Use a can of nonmentholated shaving soap. To sustain interest, sprinkle on powder paint. Add a few drops of water when it begins to dry.

 Good for 2-year-olds. Will·not harm if some goes into the mouth.

6. Hand lotion or toothpaste. Combine the above with food coloring.

 Do not use food coloring at school as it can leave a stain on the hands. Use on cookie sheet.

7. Cold cream or Vaseline. Use on a cookie sheet.

 Great for small children who have the urge to be messy.

8. Chocolate pudding. Mix up instant pudding and put dabs of it in the bathtub with the baby. With nursery school children, you can pretend it is brown paint and watch them "discover" what it really is.

It's fun to observe those who use all the senses and make the "discovery" first. *Variation.* Butterscotch pudding or vanilla pudding with food coloring added.

Mixing colors Using only two colors at a time, let the children discover what happens when they are mixed on the paper. Encourage young children to name the colors. Enjoy with them the delight in discovering that blue and red make purple, red and yellow make orange, red and white make pink, black and white make gray, and red, yellow, and blue make brown.

Many ways we can use our hands Encourage experimentation on the part of the children. They can use the palm, fist, knuckles, side, and wrist, as well as the fingers. Using the fingers, they can make dots with fingertips and thin lines with the fingernail. They can experiment with different strokes—wavy, zigzag, broad, and so on.

Alternatives to hands To achieve the special value of handpainting, hands should be used. But for the young child who is reluctant to get his or her hands "dirty" or the older child who wants special effects, suggest using.

Wadded paper.	Q-tip.
Notched piece of cardboard.	Comb.
Piece of sponge.	Pencil.
Old hair roller.	Corncob.
Small rag.	Potato half.

Handpainting Variations

- Sprinkle on sand, glitter, or salt (gives glitter).
- Lay cut or torn pieces of paper on the wet painting to make a design or picture.

- Let the painting dry and add more color with a paint brush.
- Make a second handpainting on top using a different color.
- Handpaint over squiggles of crayon.
- Double designing—child smears a couple dabs of paint on the paper and folds it over. See Spot Painting earlier in this chapter.
- "Pull a print" just for the fun of monoprinting. This is best done with plain newspaper or lightweight paper. Simply press the clean paper onto the painted design, and carefully lift. Dry flat or hanging. When dried, may be ironed face down.
- Music interpretation. Children listen to a selection of music and decide what the "color" of the music is. Consider symphonies, jazz, folk dances, lullabies, waltzes. They then start painting with that color, moving their hands to the rhythm of the music. Consider a dry run, having them just move their arms to the music. Discuss what the music makes them feel like.

A good finger painting experience should be a hundred swirling adventures, each wiped out for a new one. (81)
CORNELIA HOLLANDER

Printing can be either extremely simple or extremely complicated
—and thus it can be a worthwhile pursuit
from a child's fourth year onwards,
throughout his whole life. (86)
LOTHAR KAMPMANN

17
printing

A print is an impression made by an object onto the surface of another object. Therefore, three items are always necessary: the paint or ink, the paint carrier, and the object receiving the paint.

Printing develops awareness as the child discovers the textural effects of different printing techniques and the reversal of the design on the printed surface. It can also stretch the imagination and encourage inventive thinking. Rhythmic or systematic printing develops design ability.

The printing process allows the child to reproduce over and over something worthy of duplication.

Monoprinting and stamping are the two print-making processes most appropriate for young children.

Monoprinting indicates one print or design and is commonly associated with finger or hand printing. Finger paint is applied on a smooth, flat surface such as a tabletop, piece of glass, or cookie sheet. When the child completes his or her design, a lightweight piece of paper is placed directly on the wet painting. The painting is transferred to the paper by pressing with the hand.

"Pulling a print."

This process is also called "pulling a print" because the paper is pulled up to reveal the print. When the paper is dry, it can be placed face down and ironed smooth.

Stamping, as the name implies, is the process of pressing the "stamp" against the surface of the art paper. A great many objects that can be used for stamping are included in the activities listed later in this chapter.

The younger child will simply experiment, printing at random, with no consideration for design. Older children may repeat combinations in organized patterns to make an all-over design. It can be suggested that they arrange the units in vertical, horizontal, or diagonal rows or find their own ways to organize them. A starting

point is to have them look at repeat designs in clothing, draperies, wallpaper, and so on.

With small children, Mattil (96) suggests having them "walk" the potato (or whatever tool) across the paper and back again, in orderly even steps. They can even practice "walking" the potato before applying paint.

Uses, Surfaces, and Inking Methods

Printed papers can be put to many uses: gift wrapping, invitations, place cards, greeting cards, place mats, napkins, notebook covers, program covers, bulletin board backgrounds, posters, and coverings for storage boxes. Also consider printed fabrics such as aprons, neckties, napkins, and T shirts. This process is ordinarily used when a number of reproductions are needed.

For printing surfaces, the following may be used:

Colored construction paper.	Rice paper.
Oatmeal paper.	Paper towels.
Newsprint.	White drawing paper.
Newspaper.	Paper painted by child.
Typing paper.	Cotton or silk cloth.
	Shelf paper.

Provide ample supplies of inexpensive paper for enthusiastic children.

When stamping a print, put the sheet of paper over a cushion of newspaper.

Following are methods of "inking" the objects to be printed:

1. Direct brush application of paint.
2. A saturated paint or ink pad. Make a pad by folding an absorbent piece of wet cloth or a paper towel to fit a shallow dish or jar lid. Brush *thick* tempera paint onto the pad or sprinkle on powder paint. Add water if paint dries. Have a separate pad for each color to be used.
3. "Paint plate" and roller: spread paint on a smooth surface (cookie sheet, masonite square, piece of glass) and use small paint roller (also called brayer) to transfer paint to the object to be painted.

Printing Activities

These printing activities are listed according to the material used rather than the process involved. Basically, printing experience should progress from the simple to the complex; from simple handprints and finger prints, to stamping objects, to relief printing, and marbling.

Finger and handprints Use office stamp pad or paint pad for finger prints. The little paint cups of the water paint box make ideal paint pads for the fingers. For handprints, brush paint directly on the hand and press hand on the paper.

Sponge printing Small pieces with flat planes are most suitable. They can be precut into geometric or holiday shapes (hearts, stars, bells, trees). Dampen before use.

Stick printing Also called wood printing. Use spools, pencils, dowels, small blocks, popsicle sticks, checkers, clothespins, and such. The wood can be stamped, twisted, or slid over the surface of the paper.

Gadget printing Collect assorted household objects. Have a special box at school for such odds and ends as buttons, forks, bottlecaps, potato mashers, large nailheads, corks, screws, thumbtacks stuck in a block of wood, hair rollers, keys, jar lids, lego blocks, and wire whisks. Make a test print on blotter or newspaper to remove excess paint. For variety, swirl the gadget and layer the patterns. *Variation:* Press "found" objects into styrofoam and use with water-base ink or paint.

Vegetable and fruit printing Use carrots, cucumbers, onions, green peppers, mushrooms, celery stalks, apples, oranges, lemons, and even lettuce leaves, as well as potatoes, which will be discussed separately. With the young child, use the total surface of the cut vegetable rather than trying to cut a design into it. For a clear print, the vegetable should be cut smooth and clean and repainted each time it is printed. Let the child discover this.

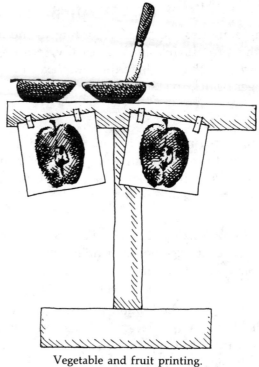

Vegetable and fruit printing.

Potato printing To cut a design into a potato, the child can use a spoon, beer can opener, pencil, nail, blunt scissors, melon scoop, or serrated plastic knife. The young child is satisfied with gouging holes or cutting criss-cross lines. Use newspaper to blot excess paint from the stamp. If it is to be used the next day, keep it in cold water in the refrigerator. Sweet potatoes and turnips may also be used. Since potatoes are porous and retain color, have a separate stencil for each color you apply. A word of caution: Be very sensitive to the economic level of the children you are working with before asking them to bring food (or any other) items to school for art projects. You may avoid hard feelings.

Eraser and cork printing These may be used as they are or cut into halves or quarters to obtain a variety of sizes. The teacher can precut designs into corks or art gum or rubber erasers with a sharp knife or razor blade.

Paraffin and soap printing A simple design is carved into a bar of soap or paraffin block, using a tool such as an orange stick, hairpin, or nail. The surface of the paraffin should be very smooth. A cloth saturated with turpentine will help to smooth it. With brush or roller apply paint, to which some liquid detergent has been added to prevent running off the block. *Variation:* Make a plaster of Paris block about ½ inch thick and carve a design in it with a nail. Coat the block with clear varnish or shellac to keep it from absorbing the paint.

Clay printing On the flattened side of a chunk of clay, the child draws a design with a pointed tool such as a pencil. The decorated side is gently pressed onto the paint pad and then printed. Soap or cleanser added to the paint will help it stick.

Leaf printing Also called nature printing. Weeds and leaves are collected and glued with veining up on a cardboard, and a brush or roller is used to apply the paint or ink. Overlap the leaves or use several paint colors to make a more interesting composition. Consider other natural objects such as seaweed, feathers or shells.

Cardboard printing Shapes cut from cardboard are glued onto a square of cardboard to make a picture or design. Paint is applied with a roller or brush. Place paper on top, rub with spoon and lift off carefully.

Textile printing Cut up heavily textured materials (upholstery fabric, burlap, wire mesh, lace, net) and arrange on a piece of cardboard. Glue down and apply paint with roller. Place paper on top and rub firmly with spoon bottom.

Collage printing Similar to the above, with the addition of such objects as buttons, coins, paper clips, and string.

Styrofoam printing Styrofoam, such as is used for packing, can be gouged with a large nail, a screwdriver or a dull table knife to make a simple picture or design. Paint can be rolled onto the styrofoam with a roller and then paper placed on the "inked" surface. Rubbing the paper with a spoon will create a colored background with the design appearing white.

Glue printing Make a design with contact glue or white glue on a piece of wood or cardboard. Let it dry until the glue is hard, and then apply paint with a roller to the raised design. Place paper on the design and press with bottom of spoon, being careful not to press in the spaces between the lines.

Roller printing The roller is a cardboard tube, tin can, rolling pin, hair curler, cob of corn, or small paint roller. It can be rolled across the paper by holding the ends or holding a stick put through

Roller printing.

it. String or cardboard shapes are glued on the roller, and when the glue is dry, paint is applied with either a brush or the paint plate. String can also be wrapped tightly around a rolling pin and the ends fastened with tape. *Variation:* Wrap string wet with glue or paste around a wooden block to form a design.

Carbon paper printing Use it under the drawing paper, carbon side up, to get a print that is reversed, or use it on top of the paper, carbon side down, for a regular print.

Crayon printing A sheet of paper is soaked in turpentine and laid over a drawing done in heavy crayon on fine sandpaper. When pressed or rubbed, a mirror image in delicate pastel tones will result.

It should retain color for about five "pulls" and then can be re-colored for more prints.

Marbling This is an interesting type of printing process for the somewhat older child (about 6 years and on). In small jars mix oil paint with turpentine to the consistency of thick cream. (Oil paint can be made by mixing powder paint with linseed oil.) Water is placed in a shallow pan, such as a cookie sheet, and the colored paints are dropped onto the surface or flipped on with a brush. A sheet of paper is laid slowly on top of the water, and when the paint adheres to it, it is carefully lifted up and set aside to dry. Any curled painting can be pressed with a warm iron to flatten it. Children tend to get terribly excited about the results and love to keep experimenting to "see what will happen." Have plenty of paper on hand in a variety of colors and textures. The finished product can be used for greeting cards, party invitations, and to cover boxes and notebooks. *Variation:* Put the water and paint mixture in a small bucket and dip hard-boiled eggs or small jars to create unique decorations.

The mess accompanying all art activities will be in exact ratio to one's failure to think ahead.

Some helpful ideas and inspiring illustrations are found in such books as:

Printmaking (106)
Creating with Printing Material (86)
Printing for Fun (100)
Simple Printing Methods (71)
Potato Printing (110)
Print Art (114)
Paper, Ink and Roller (113)

Clay has an almost magical attraction for children.
The meaning of clay play does not
lie in the functional use
of what is produced but in the play itself. (107)
ERNST ROTTGER

18
modeling and carving

MOST of this chapter deals with a wide variety of modeling media, everything from natural potter's clay to edible play dough cookies. Included are plasticene, play dough, cornstarch "clay," sawdust "clay," baker's "clay," paraffin, whipped soap, papier mâché, peanut butter balls, and others.

Sometimes a child who shows little interest in drawing or painting finds much satisfaction in working with clay. In addition to the total involvement that most children encounter in manipulating a material "in the round" or third dimension, it helps in relaxing tensions as feelings of hostility and aggression may be worked out through the pounding, squeezing, pinching, and poking of the material. Children who have been pressured about cleanliness may freely work out their inhibited feelings through playing or more often "messing" with soft clay used in conjunction with water.

Natural Clay

Natural clay is sometimes called firing or pottery clay. Although it can be bought dry, it is simpler to buy it already mixed. Having a water base, it will dry when exposed to air, so store it in an airtight container (heavy plastic bag, garbage pail with lid, coffee can with lid). To keep the clay moist, a damp sponge or towel can be placed on top, and if it gets too moist or "gooey," leave the container open to the air for a few days. Be sure to test it often. Clay should be soft enough for the child's easy finger pressure but not so soft that it is sticky.

Additions to clay Clay that is not to be fired can be made more durable by the addition of powdered dextrine (1 tablespoon to 1 pound of wet clay). The dextrine should be made from yellow corn; white dextrine is not satisfactory. It may be worked into

wet clay and, when dry, the clay is almost unbreakable. After drying, the clay is not reusable.

Adding sawdust to clay will make a lighter weight medium with more strength and an interesting texture. Dried clay that is unfired may be pulverized with a hammer or rock, covered with water for several days, kneaded, and then reused. Store clay in covered coffee cans or covered plastic pails.

Air bubbles should be removed from the clay before sculpting with it. Cut the clay into pieces and slam each piece against the table several times. This process is called wedging and can be delightful fun for children.

Working surfaces The following are suggested

- Old bed sheet over a table. Simply shake it off when the clay becomes dust and toss it in the washer.
- Individual "work boards" from scraps of plywood or Masonite (use the back side). A little sand on the board helps prevent flatware from cracking.
- Individual mats of canvas or the back side of oilcloth.
- Small household turntable. They are about 10 inches across and ½ inch high and are available in most variety or department stores. A turntable enables child to work on all sides of the sculpture without lifting the piece.

Cleaning up Remember that clay clogs water pipes, so when cleaning up, rinse as much as possible into a pail of water.

Introducing the clay Children are thrilled to see how a piece of twine or wire can cut a chunk of clay into working pieces. Give each child enough clay to use with both hands. Ideally, it should be a chunk the child can get both hands completely around. A round smooth ball can be unprovocative.

Encourage experimentation to find out what the clay will do. Allow lots of time for this pushing, punching, pulling stage. The child can learn to roll, knead, twist, split, and bend the clay. Do not look for recognizable things at first, although they often rapidly emerge.

With the young child, fingers are the best tool to use with

Give each child enough clay to use with both hands.

clay, but other tools are useful for cutting and texturing. Orange sticks, tongue depressors, and nails may be used to form basic shapes. A slab of clay that the child may pat into a flat shape can be used for exploring textural effects made by buttons, beads, fingers, shells, bottle caps, forks, screws, burlap, screening, hair rollers, dowels, and bark. Fired clay stamps made by the children can also be used to give texture. Surface ornamentation can be applied—strips, rolls, small balls of clay. The child can learn to wet both surfaces with a brush or finger when joining two pieces of clay. The appearance of hair and fur can be made by pushing clay through a sieve or garlic press.

The very young child should not be expected to "make something," but older children can be encouraged to try people and animals. It is well to remember that since clay is a heavy material, the objects should be bulky in appearance and stand by themselves on thick legs if they are three dimensional. For inspiration, the children might enjoy the imaginative clay beasts in *Gargoyles, Monsters and Other Beasts* (105a).

No two children will tackle clay modeling the same way. Some may just squeeze it and watch for a shape to emerge; some will pull out shapes from the basic form; some will add pieces and build. Some may like to add texture to their sculpture and others may not. Let's allow room for these differences.

Popcorn sculpture is an intriguing clay activity suggested by Larson and Rodgers (94). The child examines irregular pieces of

popped corn and chooses a favorite piece. The task is to sculpt the popcorn shape out of a small ball of clay (about the size of a small orange). The clay is poked and pulled, small lumps are added to it, or pieces are cut away with a dull knife.

If forced to produce a model for children, keep it at the child's level and destroy the example immediately. Remember to keep your hands off children's artwork, be it clay or any other medium. If you must make suggestions, make them in the form of questions. It is what is happening *within* the children that must be kept in mind. When we touch their artwork or make unasked for suggestions, we are telling them that their ideas are not quite good enough. The self-image suffers.

Finishing touches All clay objects that are to be kept should be dried slowly at room temperature, away from hot or cold drafts. Depending on thickness, an object may take a week or two to dry. When dry, it can be left natural, rubbed with floor wax, or painted with tempera. (It can be painted when wet, but not as satisfactorily because the colors tend to run.) The paint may be thinner than that used on paper because dry clay will absorb a lot of water. The color can be preserved with a coat of nail polish or shellac. A special brush should be used for shellac and cleaned with denatured alcohol. If a leg should break off a sculpture, it can be attached with Elmer's glue. For those who want to get into the baking of clay, glazes, and decorating ideas, the book *Potterymaking* (72a) is suggested.

Plasticine "Clay"

Plasticine "clay" is also called oil or modeling "clay." Its oil base makes this "clay" nonhardening, so it does not dry and cannot be fired. It is more expensive than natural clay, and some brands are difficult for little hands to manipulate—it becomes very firm in cold weather. When painting the plasticine, use a water-base paint to which a little pure liquid soap has been added. This mixture can be used when printing with plasticene shapes or designs. When the plasticene gets old and hard, it can be softened by warming it up and "working in" a small amount of glycerine or Vaseline from the drugstore.

Play Dough "Clay"

Not a substitute for clay, play dough "clay" is cleaner and more familiar than natural clay, so to a shy, hesitant child or one who is inhibited by cleanliness, it offers less of a threat. It may serve as a bridge between the use of clean (nonthreatening) materials and the messier ones such as clay, fingerpaint, mud, and wet sand. Eventually, the shy child may be able to use the messier materials quite happily and work out his or her inhibitions. Even if the

dough is presented without the use of tools, sensory experience is more limited than in the use of clay, as dough is not adaptable to smearing.

There are many types of recipes; this is one of the quickest and simplest:

You need: 3 parts flour (nonself-rising wheat flour)
1 part salt
1 part water
3 tablespoons salad oil

You may vary the size of the recipe, but keep the proportions exact. Mix the ingredients until pliable. To color the dough, add food coloring to the water. Stored in an airtight container, play-dough will keep about two weeks. To keep for several months, add 1 teaspoon of alum for each 2 cups of flour. Use more salt and less water when the children want to model small objects to harden and later paint. If this recipe is being used at school, double

or triple it. It is important that each child have an ample quantity (the size of small grapefruit).

Vary the way it is used, as the following:

- Often have flour in shakers for the children to use along with it (an added sensory experience).
- Use sometimes with tools and sometimes without.
- Use standard size rolling pins.
- Encourage experimentation in texturing the dough (kitchen gadgets, buttons, and such).
- At school, use it in conjunction with the housekeeping corner and provide cookie cutters, small muffin pans, and such. (It can corrode the metal doll dishes and take the paint off, so do not leave it in too long.)
- Have the children take play dough along on walks or to the beach and stick small found objects in it.

Encourage the children to gather all the dough into a ball and help put it away when they are finished playing with it.

Cornstarch—Soda "Clay"

This variation of play dough has the following advantages:

- It will keep a month or two if stored in a plastic bag or airtight container.
- It is gentle to hands. (Doctors recommend both the baking soda and cornstarch to soothe skin rash.)
- Colorability—food coloring or tempera paint may be added to the water or it may be left white and colored as a separate operation. The clay takes any kind of paint, crayon, or felt-tip marker.
- It hardens overnight or within a half-hour if placed in a warm, turned-off oven.
- It is safe if hands go in the mouth.
- It will not stain clothing, and crumbs are easily vacuumed.
- It makes attractive holiday gift objects, decorations, beads.

Following are two recipes for cornstarch clay.

Recipe #1

2 cups (1-pound package) baking soda
1 cup cornstarch
1 1/2 cups water

This recipe is for two or three children. Combine in a sauce pan, heat to boiling, stirring constantly. Remove from heat as soon as the mixture reaches a doughlike consistency. When cool enough to handle, knead lightly.

Recipe #2

2 parts table salt
1 part cornstarch
1 part water

Mix and cook over low heat until stiff. Add a few drops of cooking oil to delay drying.

Vegetable coloring can be added to both these recipes.

Two ideas for this clay are molding beads, using drinking straws to make the holes, and making "surprise" balls for the children. Divide clay into balls about the size of golf balls. Hide a drop of food coloring or tempera powder in the center of each. As the child works with the ball, the color gradually and unexpectedly appears. The models or "figures" can be dried in the air (two days) or in the oven (one hour). When dry, they can be painted with poster paint or finished with shellac or clear nail polish.

Baker's "Clay"

This inedible dough is sometimes called the oven clay cookie or Christmas tree cookie recipe. This is a popular clay for ornaments, jewelry, and figurines. If a hole is desired, it should be made before baking. If the ornaments are to be hung, a paper clip should be inserted in the top before baking.

4 cups flour
1 cup salt
1 1/2 cups water

Mix ingredients and knead with hands for five minutes. Roll out, using flour and rolling pin. Cut shapes freehand or with cookie cutters or model into shapes. Clay is easily manipulated and textured.

If a piece is to be added to the clay, moisten the joint with water so that the two surfaces will stick together. The objects can be dried at room temperature or baked on a cookie sheet in a 350-degree oven for about 60 minutes. They are done when light brown in color, or when a toothpick, in the thickest part, shows them not be soft. For flat cookies, turn over while baking.

Warning: Do not half or double this recipe or make it up too far ahead. The day before is the earliest. Keep in a plastic bag or airtight container, out of the refrigerator.

The completed objects can be kept natural or decorated with felt-tip pens, enamel, water colors, food dye, or half tempera and half white glue. When dry, they can be sprayed with a nonwater-soluble fixative (silicone or acrylic) or sealed with varnish.

Sawdust "Clay"

This is the simplest, cheapest, and crudest substitute for real clay.

Mix: 2 parts fine sawdust with
 1 part dry wheat (wallpaper) paste
Add: water—enough so that a good modeling consistency
 is reached (like bread dough)

To keep it from spoiling, 1 teaspoon powdered alum can be added.

Some prefer adding water to paste to form a creamy mixture and then adding sawdust. It keeps very well in refrigerator in airtight plastic sack or container.

This mixture is good for making puppet heads. They can be modeled on the end of a stick or small dowel that stands in a pop bottle. Fruit and vegetable shapes, animal figures, masks, Christmas ornaments, and relief maps can also be made with this mixture. Work on cardboard. Allow the work to dry slowly. Otherwise it will dry on the outside, stay wet on the inside, get moldy, and smell awful. When dry, the articles can be decorated using poster paint, shellac or bits of felt, or yarn glued on.

A simple but expensive alternative to sawdust clay is a commercial product called Superwood. Water is added to make a modeling material, and when it dries, it is like real wood that can be carved, sanded, and stained.

Paper and Paste Modeling

Paper mixed with paste make 4 popular types of modeling media, which follow:

1. Newspapers shredded up can be used instead of sawdust in the sawdust clay recipe above.

2. Crepe paper "clay" can be made by using crepe paper of one color, cut into very small pieces, in place of the sawdust in the sawdust clay recipe. The crepe paper should be soaked in water several hours until soft. Then pour off the water, add the wheat paste, and knead. This clay will dry to a hard finish and can be sanded.

3. Spread thin wallpaper paste over a sheet of newspaper. When the newspaper feels damp, bend and twist it into an unusual shape. Let it dry for a day or two and then paint or decorate it. It may become an imaginary animal, an interesting abstract, or whatever.

4. Another idea is papier mâché over a newspaper armature. With wadded newspaper and tape, the child can form an animal. This is then covered with torn 2-inch strips of paper toweling that have been dipped in wheat paste thinned to the consistency of cream. About five layers of paste-saturated strips should be applied, and they can go in all directions. Wrinkles and bubbles should be smoothed out after each strip is added. Allow to dry thoroughly and then paint. The surface can be sandpapered.

As a papier mâché alternative, an impregnated muslin, called Dip'n Drape, can be dipped into water and used over an armature. It dries hard in a very few minutes. It is available in most arts

Papier mâché over a newspaper armature.

and crafts stores, but may be called by a different name, such as Craft Drape or Drape and Shape.

These methods are not for the preschool child, but for those 6 and older.

Sand Molding

With wet sand and basic utensils, the child can enjoy many hours of sand sculpting. Basic utensils may include a small shovel, a trowel or wide putty knife or spatula, and some forms for molding (buckets, paper cups, and other various size containers). Lacking tools, the child's hands will do very nicely.

A small child can learn to fill the bucket even with the rim, turn it over and rap the bottom and edges, and lift off the form. Another learning experience is to smooth on a frosting of very wet sand.

Moist sand can be put in an old box top or meat pie dish, and the child can scoop out the desired shape or make designs by pressing in and removing such things as buttons, shells, or potato masher. If desired, the design can be preserved by mixing plaster of paris to the consistency of tomato soup and pouring it gently over the design to 1/2-inch thickness. A hanging device, such as a pull tab or paper clip, can be put in the wet plaster. Allow the plaque to dry, brush off the sand, and, if desired, decorate with paint or other media.

Whipped Soap Modeling

Dissolve 2 cups of soap flakes in ½ cup of warm water and whip to the consistency of stiff whipped cream. Use as simulated snow to frost cardboard, such as the candy house in Chapter 23. Working on foil, children can make simple objects with this material, and while it is drying they can use spoons, knives, and other tools to make designs. It is best to wet hands before molding with this mixture. A recipe variation is 3/4 cup soap powder with 1 tablespoon or so water. Beat with an electric mixer to a claylike consistency. This "soap clay" is fun to mold into figures and other objects. It dries to a hard finish.

Paraffin Modeling

Melt paraffin over hot water and pour into a container. When it has solidified but is still soft, model with it. Dipping hands in warm water from time to time will help keep it soft. When the object is modeled, dip it in cold water to harden and polish the paraffin. For color, crayon shavings or crushed colored chalk may be added to the paraffin while it is melting.

Cookies as "Clay"

The sensory and therapeutic experiences offered by clay can be achieved to some degree by cookie making. Of the many recipes that could provide this experience, three are given here as examples. The mixing, rolling, and shaping can all be done by the preschooler, but the adult will need to help with the measuring.

Edible Play Dough Cookies

Although this recipe requires baking, it is included because it can be used like play dough up until baking time.

Sift together:	3 1/2 cups flour
	1 teaspoon soda
	1/2 teaspoon salt
	2 teaspoons ginger
	1 teaspoon cinnamon
	1/2 teaspoon cloves
Cream:	1/4 cup margarine
	1/2 cup brown or white sugar
Beat in:	1/2 cup dark molasses
	1 egg
	1 tablespoon water

Add dry ingredients 1/4 at a time. Work in last 1/4 by hand. Form into large balls. Compress firmly. Roll, press, cut, or shape into forms 1/4 inch thick. Place on two large greased cookie sheets. Bake 10 minutes in an oven preheated to 350°.

No Bake Orange Balls

1 package (7 1/4 ounce) vanilla wafers (crushed)
3/4 cup grated coconut (suggest unsweetened)
3/4 cup powdered sugar
1/2 cup (thawed) frozen orange juice concentrate

Mix dry ingredients and stir in orange juice. Children enjoy forming 1-inch balls and rolling them in additional powdered sugar.

Peanut Butter Balls

Instead of an exact recipe, just an idea is offered here with the hope that it will free the makers to come up with many variations of their own. Have the children do the following.

Mix:	equal parts of peanut butter and powdered sugar to form balls
Roll the balls in:	chocolate sprinkles or
	nuts or
	fine coconut or
	similar items

Other ingredients too can be added to the peanut butter mixture, such as flake coconut, instant dry milk and graham cracker crumbs. Add ideas of your own. Experiment with using only sugarless ingredients, such as unsweetened coconut, sugar free grahams, carob powder, date bits, or raisins.

CARVING

Carving is an activity that is not often offered to the young child because more appropriate art activities take precedence and because of the assumption that sharp knives have to be used for carving.

With soft carving materials, such implements as spoons can be used quite satisfactorily. The very young child might begin by carving clay. From there, he or she can go on to carving in a vermiculite and plaster combination, which is also soft enough

for a spoon. Vermiculite is a flaky insulation material obtainable from a plant nursery or hardware store. The recipe follows:

Recipe

Mix well: equal parts of plaster and vermiculite
Add: water

Stir constantly while adding the water until the desired consistency of thick plaster results. Pour into a mold, such as a shoe box. When set up, tear away box and carve. Increasing the amount of vermiculite can delay the "setting" of the mixture and make it usable as a modeling medium.

Soap and paraffin are popular carving media for young children. Spoons, dull knives, nails, and hairpins can be used for carving and designing. For older children, Wankelman and Wigg (33) suggest gesso carving and using carving paste.

The hands lead the way to learning and logic;
the hands absorb and transmit indescribable messages
and information to the brain
in the most thorough way available to us. (115)
ANN WISEMAN

19

constructing
and woodworking

CONSTRUCTIONS are three-dimensional arrangements of materials, sometimes referred to as space designs. Children enjoy using some materials that offer resistance and that call for a greater than usual physical effort, and many in this chapter, especially woodwork, fulfill this need. Here is the chance to offer children the stimulation of a variety of materials and the joy of "making something from nothing."

CONSTRUCTION

Cardboard Construction

Box sculpture Imaginative creatures or objects may be created by fitting together cardboard boxes of various sizes and shapes. People, animals, vehicles, and buildings may result from the combinations. Masking tape, white glue, or brass paper fasteners will hold them together. Water paint (to which a few drops of liquid

Box and tube constructions.

soap have been added to make paint adhere to slick surfaces) can be used to color the creations. Or the boxes may be covered with paper of various types (newspaper, magazine ads, construction, contact, gummed back). Have odds and ends available for further decorating the construction (yarn, feathers, cloth, ribbons, buttons, popcorn, sawdust, woodshavings, leather, and such).

Paper sack sculpture is a variation in which paper sacks filled with crumpled newspaper are used in a way similar to the cardboard boxes. Another variation is to go "creative" with just one type of carton, namely the egg carton.

Cardboard tubes Creatures and characters can be made from bathroom tissue tubes and paper towel tubes plus a few additional materials, such as construction paper, pipe cleaners, wire, toothpicks, cotton swabs, and paint. Older children can make a point at one end of the tube by cutting several slits about 1 1/2 inches deep, pointing them with the scissors, and gluing them to form a point. These are handy for rockets, pointed faces of animals and so on.

Cylinder cities are made from a variety of cardboard tube sizes up to hatbox size. Small wooden dowels or pencils stuck through holes in the side of the tubes hold the city together. Paint

provides doors and windows if desired. A good illustration of this type of construction and many others is shown in the Whitman art book titled *Constructing #1* (114).

Cardboard box vehicles A large carton can become a car, boat, plane, or space ship, with the child's imagination and a little help from you. This is a nut and bolt activity that gives the child much manipulative exercise. Provide him or her with nuts and bolts (about 2 inches x 1/4 inch) and a variety of discarded gadgets— old light switches, stove dials, cottage cheese lids, spools, radio controls, door locks, timer dials, and especially a toy steering wheel. The adult needs to make holes in the carton large enough for the bolts and the switches. The child can take it from there and may even want to paint the vehicle. Several of them attached together can make a great train for a nursery school group. When interest wanes, toss out the carton and save the gadgets for another time.

Constructions from Other Materials

Discarded materials Discarded materials are better referred to as "beautiful junk." This means anything you have left over, especially three dimensional (plastic spools from cameras, milk cartons, cellophane tape dispensers, all types of kitchen salvage, clothespins, corks, beads, spools, bottle caps, plastic coated wire, broken toys, and so on). As there are no rules for beautiful junk constructions, the creator is free to use his or her imagination and express ideas that are truly personal. The adult should not value representational results, but rather originality in organizing the materials and persistence in joining and affixing them.

Here is a recipe for the ecology-minded to help children become trained in recycling the products of our throw-away culture. By Sylvia Burns, it is from a unique little booklet *Bits and Pieces* (65).

Basic Recipe
for Using Leftover Materials

The ingredients are:

one part foresight
one part unstructured attitude

one part leftover items
children (number varies
according to kind of material and interest)

Procedure: Have foresight to collect and save interesting leftover items. Pay special attention to those made of wood and metal, to be found at home, on trips round the neighborhood, or acquired from friends and relatives. After thoughtful selection, prepare the materials for use by scrubbing, sanding, oiling, removing rusty nails, tightening or replacing nuts and bolts or making other necessary adjustments. Enlist children's help when possible.

Preserve an unstructured attitude toward their use. Do not abuse leftovers by predetermining their function, no matter how obvious they are. Blend leftover items and children in activities whenever possible.

Fruit and vegetable figures Children of all ages really enjoy this activity, especially if a little nibbling is permitted along with it. Begin with a base of a fruit or vegetable for the body. Provide also an assortment of nicely shaped leaves and dried fruits, such as raisins, dates, and prunes. These become hair, arms, ears, and other parts. Whole cloves, gumdrops and marshmallows may also be included for facial features. It is not as expensive as it sounds because the results may later be eaten. Toothpicks are best used

Fruit and vegetable figures.

for the joints, but older children may also want to use straight pins. These figures make delightful little creatures.

Marshmallow structures A variation is to give the children a pile of large and small marshmallows and toothpicks and let them "go creative." Raisins and gumdrops may also be included.

Toothpick sculpture With a box of flat toothpicks, a cardboard base, and fast-setting household cement, a child of about 6 or 7 can make very interesting constructions. Any small sticks may be substituted for the toothpicks, such as Q-tips, popsicle sticks, or clothespins. Younger children enjoy making cork and toothpick animals or soap and toothpick figures. The soap may be precut into small pieces, and the child can do additional carving with a spoon or dull knife.

Straw structures Ordinary drinking straws are challenging and stimulating and can lead to artistic constructions. Encourage twisting, pleating, bending, cutting, and curling them. Join by pinching the ends and using glue for paper straws or household cement for plastic straws. They can also be connected with gumdrops or little marshmallows.

Pipe cleaner figures Animals and people are the two favorite figures from pipe cleaners, but some children like flowers and abstract forms. All that is needed are pipe cleaners, preferably in a variety of colors, and scissors. One way to shape the pipe cleaner, such as for an animal body, is to twist it around a small object like a pencil or cardboard tube. Thickness can be added to stick figures by wrapping additional pipe cleaners around the body. Some like to use pipe cleaners in conjunction with other materials, such as styrofoam blocks or tiny styrofoam balls. The latter can be used as heads, and older children may add hair from yarn or paper scraps and make clothing from bits of cloth and gift wrapping.

Wire sculpture This is closely related to the use of pipe cleaners, which are just covered wires. Working with wire gives the experience of making line drawings in the air. Give the child any substan-

Top, a pipe cleaner figure; *left,* toothpick sculpture; *right,* wire in clay sculpture.

tial wire with some flexibility, a cutting tool, and a pair of pliers for pinching wires together. Small children can work with precut lengths. Encourage experimentation with the wire, including wrapping it around things. It can be stapled on wood scraps or stuck into clay for a base. With young children, the teacher can staple a loop of heavy wire on a piece of wood as a base for the child to create a design of fine wire.

Rock creatures Fun animals and people can be made by joining together rocks of various shapes and sizes. The skill required for joining the rocks with epoxy glue may eliminate very young children from this activity. The rocks need to be clean and dry. Felt-tip markers may be used to make the face, and the imagination may be used to think of other ways of decorating the rock creatures. If the rocks are painted, add some glue to the paint to help it adhere. Fine wire for whiskers or yarn for hair can also be attached with white glue. To avoid joining rocks together, have children use medium size stones with interesting shapes and create a face

on one side. Most of the rock should be left unpainted to reveal natural colors. They could be used for paperweights.

Nut animals Nuts also can be combined to make figures. Felt ears, feet, and tail can be glued on. Pipe cleaners can be used by making a little hole in the shell and inserting a piece of pipe cleaner with a little glue on it.

Pine cone characters Starting with large pine cones, create people, birds, and animals with the use of white glue, felt scraps, colored toothpicks, pipe cleaners, yarn, nylon net, feathers, and construction paper.

Foil figures Household aluminum foil can be crumpled into individual forms and assembled with transparent tape to create a figure or piece of sculpture. Brass paper fastners are useful for joining parts together and for such things as eyes. Pipe cleaners make tails, wings, stems, and so on. Details can be painted on with colored fingernail polish, or the whole thing can be painted with a mixture of liquid detergent and tempera paint. Extra decorative materials may be added with household cement.

Kites Kite making is a popular construction activity these days. But most of the building instructions are too complex for the 3 to 8-year-old. However, there are three usable suggestions offered in the Sunset book, *Children's Crafts* (111). They are: a lunch bag kite, a garbage can liner kite, and a triangular bird kite made with tissue paper and bamboo.

Mobiles Most of the above constructions could be considered stabiles in that they are nonmoving. Mobile constructions are designs that move in space when hung. This movement produces changing patterns. Below are a few simple suggestions.
The *support* (what the objects are hung from) may be

• A heavy cord stretched across the room.
• A tree branch.
• One to three wire coat hangers used as is or twisted.
• A free-form wire shape.

- A sturdy piece of cardboard with lots of holes in it hung horizontally to the floor.
- A piece of onion sack or heavy net hung from the ceiling.
- Three dowels or tree twigs, the first hung by a string in the middle and the other two hung similarly from the two ends of the first stick. This is an exercise in balance.

Objects to be suspended. They are also called floating shapes. (Use nylon thread for hanging, string or yarn for younger children.) Remember that the most effective mobiles contain objects having some kind of relationship to each other.

- Birds, from tree branches—cutout paper birds, birds of pine cones and feathers, birds from two identical shapes of tough paper stapled together and stuffed with wadded newspaper.
- Decorative items such as: torn paper collages, cut paper shapes, pipe cleaner designs, toothpick or straw structures, foil figures, small decorated boxes, and cut up paintings or drawings.
- Yarn forms made by dipping short lengths of yarn (not wool) into diluted white glue, wheat paste, or starch and dropping them into interesting shapes on waxed paper. They will usually dry overnight, and then the paper can be peeled off. If any of the pieces pull apart, they can be mended with a touch of white glue.
- Yarn bubbles, made by wrapping paste-saturated yarn around small balloons. After the yarn is dried, the balloon is popped,

Yarn bubbles.

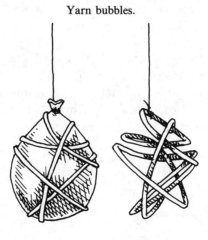

and you have a yarn bubble. A simple cutout construction paper bird can be hung on the inside.

Found objects such as buttons, seashells, rocks, driftwood, nails, bolts, metal pieces, feathers, ribbon, tongue depressors, keys, paper cups, old movie film, spools, corks, cutup cherry tomato or berry baskets, wire screening, tinsel, Christmas tree balls, Easter eggs. Good illustrations and additional ideas can be found in the little book *Mobiles* (118).

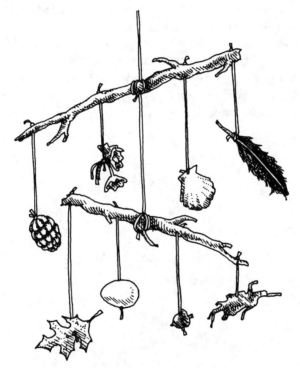

Found object mobile.

The book *Creating Art from Anything* (97) will stimulate the child or adult to see possibilities for constructions in almost everything.

WOODWORKING

Woodwork is of value because it releases tension, promotes hand and eye coordination, stretches the attention span, develops respect

for tools, provides social contact, and stimulates the imagination, if the child is encouraged to use it.

A first step in woodworking is to let the child play with the various sizes and shapes of wood and make arrangements with them. He or she may then want to glue them together. Balsa wood pieces joined by toothpicks can make interesting arrangements. Quick-setting household cement can be added to the toothpick ends to make the structure stronger. Sandpaper for rough edges and tempera paints may be available for those who want to put finishing touches on their designs.

Tools may be introduced next, starting usually with the hammer. The child will first be interested in the tool itself and should be allowed a period of experimentation with it before being asked to make something. For instance, 3- and 4-year-olds love simply to pound nails into tree stumps or rounds.

The very young love to pound nails into
tree stumps or rounds.

Suggested Tools and Supplies

Give real tools of good quality. Avoid toy tools and inferior tools as they can be frustrating and dangerous. The following tools and supplies are suggested:

Wood supply Check with junior high school shops and cabinet shops. Use scraps in a variety of shapes and sizes, but not more than 1 inch thick or more than about 10 inches long. White pine is most recommended for preschool because it is soft. Also include balsa wood, garden stakes, lath, apple crates, cut-up broom handles or doweling (for wheels), spools, and tree rings. Avoid plywood and plasterboard. Some teachers include styrofoam. The children saw it and use nails or toothpicks as tacks.

Hammer Regulation claw hammer about 13 ounces in weight with a secure head. Check the hammer head often.

Nails Large flathead nails in a variety of sizes. Too long a nail can be frustrating. The sizes of the pieces of wood to be joined should determine the nail size. Too large a nail would split a thin, narrow piece of wood.

Saw Crosscut, not more than 15 inches long, sharp and rigid, made of high carbon steel with perfectly set teeth.

Vise Holds wood for sawing. The child should learn to saw fairly close to the vise to prevent vibration.

Workbench Sturdy, approximately 24 inches high, overhanging edge at least 1-inch thick and deep enough to support a vise or C-clamp.

Other materials To encourage woodworking, offer a fairly large screwdriver and an assortment of screws, a nail punch, a brace and bit, sandpaper, rasp, measuring tape, ruler, level, pencil, bottle caps, detergent caps, and paint. (One way to initiate the use of the screwdriver is to offer an old alarm clock to be taken apart. The insides may be nailed to wood.) Carpentry aprons may be used to restrict the number of children at the workbench. A pegboard mounted on the wall or the inside of a door is a safe way to care for tools.

Keep in mind that if you are tense in the carpentry area, the children may tense up and do something silly to relieve that

tension. Also remember to not let the use of the tools get in the way of the child's natural creativeness. Tools are a means to an end, not an end in themselves. *Helping Young Children Learn* (102), Chapter 6, is recommended if you want more guidance in the area of woodworking.

> *Wood is a living material and the child likes the feel of it.*
> *He likes to touch it and even to smell it.*
> *With a little guidance, he can learn*
> *to take a simple block of wood, sand it,*
> *smooth, wax it, and buff it . . .*
> *he can learn about fine craftmanship. (68)*
> CLARE CHERRY

Needlework, like any other medium,
seems to lose its uniqueness
when it's imitative. (91)
NIK KREVITSKY

20

stitching and weaving

YOUNGSTERS can learn to use the needle as a brush, the yarn as paint, and the burlap as canvas. They can start stitchery at three and sometimes younger, and weaving a year or two later. Three-year-olds can be introduced to needlework through stringing activities. Start with stringing macaroni and pieces of soda straw, and then progress to two-hole stringing. Buttons can be used for this or pieces of paper with two punched holes. Use long, blunt needles and yarn, doubled and knotted.

STITCHING

Jacqueline Enthoven in her book *Stitchery for Children* (74), has an excellent chapter for the preschool-age child, amply illustrated with pictures of their work. Boys especially should be encouraged to do stitchery. Enthoven has found that they take to it voluntarily and tend to do much better and more imaginative work than girls. Another reason for encouraging boys is that most present-day

179

schooling does not educate the hands. Also, stitchery offers another means of expressing oneself.

MATERIALS OF STITCHERY

Fabrics and the like	*Threads*
Burlap (good quality).	Yarn (4 ply for beginners).
Monks cloth.	Rug yarn.
Onion sacking.	Household string.
Mesh dishcloth.	Butcher twine.
Nylon crinoline.	Raffia.
Rug canvas.	Embroidery floss.
Hardware cloth.	
Fiber glass screening.	(length of thread should
Cardboard.	be about length of arm)
Shelf paper (plastic coated, rubberized).	
Coarse cotton.	
Meat trays	
Styrofoam sheeting.	

Materials that can be worked into the stitchery are feathers, fur, dried grasses, ribbon, beads, rope, twigs, and other objects from nature.

When using the hardware cloth or screening (great materials for the preschooler), cover the edges of each piece (suggested size 6 x 9 inches) with masking tape or a colorful plastic tape.

A strip of masking tape around the back edge of cloth helps prevent raveling, as does a thin line of white glue or a zigzag machine stitch or spray starch. Spray starch can also be used on the entire back of the cloth to make it stiffer and help prevent puckering.

To make the material taut and easier to handle for young

children, provide them with a small frame or a 6-inch wooden hoop with a screw. A less expensive way to keep the material taut is to staple the edges to shirt cardboards. If using a meshed potato or onion sack, a piece of cardboard can be placed inside. When the cloth is stapled to a wood or cardboard frame, it has a finished look that is psychologically encouraging to the child. It looks like it could be hung.

The young child can also begin by using homemade sewing cards made from paper, lightweight cardboard, white meat trays, or IBM cards. Let the child make his or her own design, even if it is just a simple scribble. The adult can make perforations if necessary. A novel stitchery surface is white styrofoam flat blocks or sheeting. Be sure to tape the knotted end of the thread to the back of the foam so it will not pull through.

For *needles,* keep in mind the following points:

1. Blunt, with wide eyes.
2. Tapestry best for younger child.
3. Should be slightly thicker than the yarn.
4. Size 14 for beginners.
5. Metal better than plastic (except for very young or handicapped).
6. Needle substitutes (when using hardware cloth) include:

 a. wrapping last inch of yarn with about an inch of masking or cellophane tape, and cutting at an angle to make a point;

 b. rubbing Elmer's Glue on about last inch and twisting into a point (dry thoroughly on wax paper);

 c. dipping end of yarn or string in melted wax;

 d. using a bobby pin.

To thread the needle,

- Enclose the yarn in a small piece of folded paper, with yarn in crease. Cut paper to a point and push "pointed paper" through the needle. The same thing can be done with cellophane tape.
- Another threading trick is to moisten the end of the yarn between the lips and lay it between two pieces of dry soap. Press soap firmly while drawing yarn out. Repeat the process several times.
- Dip end of yarn or string into melted wax.

For useful ideas on knotting the end of the yarn or anchoring the yarn to the needle, see pages 18–19 of Enthoven (74).

Getting Started

The wise adult will have materials at hand for that time when the child shows the first spark of interest, as the creative spirit can be very elusive. Generally, it is best to allow children a variety of materials and colors to choose from, except for the first time when such a choice can be too confusing and time-consuming. In the beginning, thread and anchor the needle and knot the thread for the child. Do not be concerned with whether he or she starts with the knot on the front or back.

Do not give the child something to stitch that someone else has drawn. This can stifle creativity of child and adult alike.

Hardware cloth is great for beginning stitchers, but the yarn is apt to go over the edge a few times. Just think of this as part of the design and do not concern the child, for he or she will

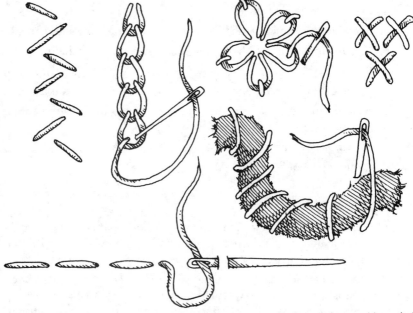

Top, left to right, zig zag, chain stitch, lazy daisy, cross stitches; *right,* couching stitch; *bottom,* running stitch.

soon catch on. The child can be helped to avoid such mistakes by a sing-song chant of "needle up, needle down" or "front to back, back to front." When the child has trapped a hoop with the stitches, he or she can be challenged to figure a way to untrap it.

Allow the child to play freely with the needle and thread and learn, as much as possible, by experimentation. He or she should have a "doodling cloth" on which to invent and practice stitches. The sensitive adult will have his or her own doodling cloth to use when teaching stitches and will never stitch on the child's work.

Some of the stitches a child may want to learn first are running, darning, chain, back, buttonhole, couching, satin, French knot, and blanket stitches. Examples of these and many more can be found in Enthoven's book (74), the Whitman book, *Stitchery #1* (114), and Krevitsky's *Stitchery: Art and Craft* (91).

Fresh designs can come from knowing the basic stitches, plus an attitude that new stitches can yet be invented. So, after youngsters have learned a few basic stitches, urge them to experiment and combine them in an original way or create new stitches. They may create directly on the fabric or sketch on it with chalk beforehand. It is best to encourage the attitude of "letting the stitches tell you what they want to do." The child might start with an idea in mind and, if allowed to let the material and thread "speak," the details will take care of themselves.

The adult might suggest the addition of different materials (see earlier list), and, if the interest span is short, the gluing on of pieces of material to build up solid areas.

Other Yarn Activities (Nonstitchery)

Yarn and glue design Create a design with yarn on cardboard and glue down.

Yarn and cardboard design Start with cardboard with slits cut about 1/2 inch apart all around the outside and three colors of yarn about 4 to 8 feet long. The first piece of yarn is run from one side of the frame to the other to form varied spaces. The same is done with the other pieces of yarn. Some of the resulting spaces may be colored if desired.

Yarn and starch Dip lengths of 8- to 10-inch yarn in starch. "Draw" (wind and drop) with the yarn on cardboard. Let dry. Or drop the yarn on wax paper and, when dry, cut around the shape and use it as a decoration (for mobile or tree ornament).

Weaving

*Weaving is especially fun
because I can feel the colors
instead of just seeing them. (104)*
FIRST-GRADER

The interweaving of threads offers the satisfaction of producing patterns in texture and color. It is a skill that is related to man's early history.

Burlap design This is a form of "short-cut" weaving that can be used to introduce children to the concepts involved in weaving.

Burlap design created by thread pulling.

A piece of burlap can be pinned to a coat hanger or stapled to lightweight cardboard. Younger children can fringe it while observing how it was woven. Older children can pull the strands so as to create designs. They can learn that the vertical threads are the warp and the horizontal threads are the weft. Spaces can be created by lifting out a pattern of horizontal threads with a rug needle. Colored yarn can be woven in or used to tie groups of threads together. Feathers, grasses, or twigs can also be inserted.

String and yarn design This is another simple beginning weaving technique that has a lot of appeal for children and teaches them the rudiments of the art.

An interesting tree branch, stick, or piece of driftwood is selected, and strings are hung from it to form the warp of the weaving. Weft yarns are woven over and under the strings. Encourage textured variation by suggesting other items to be interwoven (bark, kelp, cattails, and so on).

Loom weaving Hoover (82), in his fine book, suggests a simple loom for 4- and 5-year-olds and heavy cotton rug yarn in many colors. He feels this is much more satisfactory than paper or felt weaving, which is difficult to do and does not offer much personal satisfaction in terms of either the process or product for this age group. The book has illustrated instructions for building an inexpensive wooden loom and directions for its best use with preschoolers.

The simplest and least expensive loom can be made of a stiff rectangular piece of cardboard with notches 1/2 inch deep and 1/2 inch apart across both ends. The warp string is then wound from notch to notch across the cardboard and fastened at the end.

Usually a beginner will better understand the principle of weaving if he or she starts with just two contrasting colors and does a tabby weave, which is the simple alternating over-and-under weave. The secret of weaving is that "we go *over* the thread we went *under* before, and *under* the thread we went *over* before." After a child understands this sequence, he or she may develop new patterns by changing the over, under sequence.

With younger children, keep weaving a game at first, with no thought of finishing an article.

Branch weaving Older children may be encouraged to discover and use long reeds, grasses, strips of split twigs, cattails, kelp, feathers, vines, corn husks, bark, weed stalks, roots, and other materials from nature. They can use these along with yarn in nature weavings on natural structures, such as a triangular tree branch or a piece of driftwood with another piece at the bottom of the weaving. *Making Things* (115) has a few illustrations of such nature weavings.

Nature weaving.

Wheel weaving A popular weaving variation for the older child is wheel weaving.

Provide any large hoop for a wheel (metal, plastic or wood) and a small brass or wooden ring to use within the wheel. As shown in the illustration, the warp yarns hold the inner ring in place and provide a basis for weaving. To start the process, the warp yarn is knotted to the large hoop and then wrapped through the small hoop, going back and forth between the two for as wide a design as desired. To keep the smaller ring in position, follow the same procedure on the opposite side of the circle. Weft yarn is then interwoven in any desired pattern.

From the first grade on, the youngsters can do exciting weaving on drinking straws, pencils, scrim, and wire mesh. Examples of these and other ideas can be found in *Weaving Without a Loom* (95), a book full of inspiring photographs and easy-to-follow diagrams. It has some fun paper weaving ideas that are simple to make, but intriguing to look at.

String cross weaving Many craft books including *Weaving Without a Loom* illustrate the popular string cross or *Ojo de Dios,* which means "eye of God" in Spanish. This is a colorful diamond of yarn wound on two crossed sticks, such as branches, pencils, chopsticks or popsicle sticks. They were made by the Mexican Indians for good luck.

Directions for making an eye of God:

- The sticks are tied together with yarn that is crisscrossed and knotted.
- The diamond is formed by wrapping the yarn entirely around one stick and then continuing to the next stick and doing the same thing.
- Encourage the children to vary the colors so as to work up a nice pattern. This is done by tying a new color to one of the sticks and proceeding as above.
- When the diamond is big enough, simply cut the yarn and tie it to the stick.

Have the patience to allow children to learn through their own mistakes and at their own pace.

21

puppet making

THERE is so much "magic" in puppetry for the young child that the author felt the need to write an entire book on the subject. For a thorough treatment of puppetry and the young child, including the making and use of puppets, the reader is referred to the author's book *The Magic of Puppetry: A Guide for Those Working with Young Children* (Prentice-Hall, Inc., 1980). In it the many values of puppetry are described and a wealth of activities are offered for attaining them.

Some of the values of puppetry are: it develops the imagination and creative thinking; allows children to test life situations vicariously; encourages communication skills; helps children to recognize their own behavior; offers an avenue of self-expression without fear of nonacceptance; frees youngsters from self-consciousness, thus overcoming shyness and stuttering; increases the attention span; develops critical listening skills and the power to think quickly; and develops manual dexterity and manipulative skills. All of these values are achieved through **using** the puppets after they have been made.

Instant and inexpensive puppets are recommended for the young child. Instant because of the

- short attention span of young children and their need to see immediate results.
- importance of there being time remaining in the class session to *use* the puppets.

Inexpensive, in order to

- encourage the recycling of the wealth of wasted materials available in home and school.
- fit the budget of any parent or teacher.
- develop in children the creative thinking processes of adapting, modifying, and putting to other uses the materials in their environment. This frees them from the mind-set of just one way to use things.

Of the seven basic types of puppets (marionette, rod, shadow, hand, stick, finger, and humanette), most recommended for the young child are stick, hand, and finger puppets. Some suggestions for making these three types of puppets are offered here. Many more may be found in *The Magic of Puppetry* (83a).

Stick Puppets

The stick puppet, simplest of all puppets, is controlled by a single stick that goes up inside the puppet or is attached to the back of it. Some types of sticks that can be used are doweling, rulers, tongue depressors, tree branches, popsicle sticks, chopsticks, paint paddles, and cardboard tubes (from paper towels and such). Figures or heads, either two or three dimensional, can be attached to the stick. For young children, try faces on small paper plates or cardboard circles. Or a piece of doweling or cardboard tube can be stuck into a paper bag that has been stuffed with torn or wadded newspaper to fashion a head. The child can paint or paste on a face, add ears, hair, or whatever.

Stick puppets are also successfully made by inserting sticks into various fruits and vegetables and designing faces, with the

Paper plate and paper bag stick puppets.

use of straight pins and precut felt pieces, raisins, cloves, gumdrops, buttons, jewelry, and such.

A ruler or other flat stick inserted in the end of a sealed envelope makes another instant stick puppet after the child has drawn a figure on the envelope. The household object stick puppet is also a lot of fun. Apply imagination to using such articles as big sponges, spatulas, wooden spoons, feather dusters, bathroom bowl brushes.

Hand Puppets

There are two basic types of hand puppets—those with a mouth that moves and those with hands that move. For the very young, the type with the moving mouth is the easier to operate. Each type can be made with both paper sacks and socks. The younger child can simply glue felt facial features on the end of a sock that has finger holes cut for the arms. Or felt pens can be used to draw a face on the bottom of a lunch sack so that the fold at the bottom becomes the mouth of the puppet.

Hand puppet with moving mouth—a good use for old socks.

Styrofoam balls are a successful medium for beginning puppet makers. The adult pushes a finger hole in the ball with the end of a dowel or wooden spoon. The ball can be used as is or covered with the toe of a sock or a piece of nylon stocking. The child, using straight pins, creates the face with buttons, beads, sequins, or felt pieces. Hair can be made of fake fur, yarn, or fringe. The child can drape a handkerchief-sized piece of fabric over his or her index finger, which goes in the finger hole to create a "dress" for the puppet. The adult can make two slits in the fabric for the child's thumb and middle finger to emerge as puppet "hands."

Paper plates, small boxes, styrofoam cups, fruits, vegetables, envelopes, and mittens are a few of the other materials that make fun instant hand puppets.

Finger Puppets

Finger puppets have a lot of advantages for the young and those who work with the young. They are so inexpensive, really easy to manipulate, encourage individual finger action, are small enough

Left, finger-face puppet; *center,* finger-leg; *right,* finger-cap.

to carry easily and use when traveling or visiting, take up little storage space, are good for a child sick in bed since the use is not tiring, and one child alone can put on a performance with a whole cast.

There are three categories of finger puppets.

1. Finger-leg—index and middle fingers serve as the puppet's legs.
2. Finger-cap—slips over an individual finger.
3. Finger-face—has face, drawn with a felt pen, on the finger itself.

For the finger-leg puppet, the child creates a legless figure on cardboard and cuts it out. A rubber band is taped at the lower back, and the index and middle fingers go through it to form legs. Paper dolls with the legs cut off can be used. but it is preferable to challenge the children to create their own characters.

Finger-cap puppets can be made from 3-inch squares of felt rolled into tubes, from construction paper cylinders, peanut shell halves, or from the fingers cut off old gloves. Faces and wigs can be designed using felt pens, fabric or paper scraps, bits of yarn and glue.

Finger-face puppets, the simplest of the finger puppets, can be embellished with yarn wigs and felt or paper hats. A ribbon can be tied around the finger to represent a bow tie.

In making puppets, it is wise to keep in mind that the puppet is a means to an end, not an end in itself. It is an instrument. So let the children know why the puppet is being made or how it will be used before they begin making it. And then keep your word. Do not run out of time and forget about the use of the puppet.

There are many puppet exercises in the *Magic of Puppetry* (83a) to get the children comfortable with puppet movements before they are called upon to act out stories and poems. Simple discussion questions can get the children to talking with the puppets, and movement exercises will enable the puppets to "say things without words."

Ideally, children should have an opportunity to use puppets themselves and to see others use them before being asked to make them. The desire to make puppets grows out of having experienced them.

Remember, "the play's the thing"!
To make puppets and not perform a play
is like planting a farm and never harvesting it. (12)
KENNETH JAMESON

If we really believe in
a program of creative experiences,
this [the holiday] is no time
to bring out a "step-by-step" project
for each child to make
according to instructions. (82)
HOOVER

22

relating to the holidays

HOLIDAYS provide the motivation for much of a child's art experiences. Unfortunately, in many situations, the art is so holiday-centered that as soon as one holiday is over, preparations start in for the next.

Holidays are often peak experiences for children, and it is important that they be allowed to express these experiences in their art. This can be done after the holiday as well as before. So often, art projects are only done prior to the holiday, and it is *after* Halloween or Easter or whatever that children may have some important feelings to express, plus a greater understanding of the concept of that holiday. So have the paint, clay, and collage materials still available. Other activitites, such as creative dramatics, puppetry, storytelling, and creative writing may often be more expressive after the holiday than before.

In planning holiday art projects, it is important to keep in mind the values of art for the child as listed in Chapter 3. These should be the objectives of any art experience for children, with developing creative thinking always of particular importance.

Regretfully, the holidays are a time when "dictated art" is rampant, when the final product is predetermined by the adult. Teachers plan "parent pleasers," parents plan "grandparent pleasers," and the child becomes secondary to the product he or she makes. During these holiday projects, keep uppermost in mind what is happening within the child. How is the experience making the child feel about him- or herself.

Let us avoid like a plague all the many holiday arts and crafts books with their patterns and attractive finished products that can be made only one certain way. The only person deriving a creative experience from these is the originator. Also, let us avoid projects that require the adult to do much of the work, either before, during, or afterward. The project is not the child's then, and the child is getting the message that what he or she does is not good enough.

Some argue for adult "helping hands," saying that this is teaching the child techniques and that an attractive finished product will give a feeling of success. However, the youngster may, instead, feel inadequate and "turn off" art at an early age. Further, an art product that is not all the child's thinking and work is false representation. This is actually teaching the child to lie subtly. It is a form of plagiarism. We should not support it. Teachers need to help educate the parents and the parents the grandparents, so that what truly comes from within the child will be respected.

Gift Ideas and General Activities

What to make for holiday gifts and decorations is usually a big concern of teachers and parents. Ask the children for ideas. A discussion, in a climate that encourages free and original thinking, should bring forth a great many good suggestions. And the children will be more interested in carrying out ideas they themselves have suggested.

Here is a good opportunity for children to learn that they can create gifts and not just buy them. Too often, what is made are gimmicks and gadgets of dubious usefulness and practicality that do not express the true creativeness of the child.

For teachers and parents who need some suggestions, here is a general list of possibilities for gift giving.

- Paintings (try miniatures, painting with Q-tips, paste brushes, feathers).
- Crayon pictures of various types mounted on colored paper background.
- Collages of materials related to the holidays.
- Sculptures from one of the modeling media.
- Strings of beads made from one of the sculpture materials.
- Self-portrait; one way is actually to outline the child's body on a large sheet of paper, and let the child take over from there.
- Greeting cards; can be drawn, painted, or made by laminating forms such as tissue paper or leaves between construction paper and transparent adhesive-backed paper.
- Table mats decorated with crayons and pressed with a hot iron.
- Candles, floating or other.
- Decorative boxes; let the child go creative with paint.
- Creative cooking done by the child.
- Arrangements of dried weeds.
- Wrapping paper designed by the child, for the finishing touch.

A teacher or parent could do very well by sticking to the basic art activities and not getting involved in an overemphasis on crafts at holiday time.

BASIC ACTIVITIES THAT COULD BE USED FOR ALMOST ANY HOLIDAY

- Murals depicting the holiday.
- Dioramas. Group constructs a scene in a large cardboard box turned on its side. The opening is then covered with cellophane.
- Painting on paper cut in a shape to suit the holiday (egg for Easter, and so on), handpainting, and then laying on appropriate cutouts (black face on orange pumpkin). Seasonal music to paint by.
- Holiday tree. A large bare branch can be placed in a pail of sand, and the children can paint it with white tempera if desired. All through the year, it may be hung with decorations appropriate

to the various holidays. This can be done at home for a centerpiece by placing a smaller branch in one of the types of clay and covering the base with a felt or paper skirt.

- Hat making, from newspaper, paper plates, paper bags, construction paper. There are witches hats, Easter bonnets, Indian head-dresses for Thanksgiving, and many more.

- Window decorating. Let the children conceive of new, original ideas for this space.

- Banners and flags in honor of the holiday. The children design their own and parade with them.

- Mobiles of cut paper designs or objects related to the occasion.

Candy House Centerpiece

(No cooking required). Make a simple cardboard house, taping walls, roof, and chimney in place. Ice the entire house and cardboard base. The icing can be made from powdered sugar with a little milk added, or use 4 egg whites, 4 cups of confectioner's sugar, and ½ teaspoon of cream of tartar. Beat the egg whites with the cream of tartar until frothy, then add the sugar gradually until the mixture holds soft peaks. Spread it over the entire house and press candy into the frosting before it hardens. Consider lollipops, candy canes, chocolate chips, gumdrops, coconut, sugar sprinkles, pretzels, chocolate squares, and miniature marshmallows for win-

Left, candy house; *right,* holiday tree.

dows, doors, roof, and fence. A nonedible house can be made by frosting the house with whipped soap. (See Chapter 18.)

Cookie Making and Decorating

A simple sugar cookie "painted" makes a nice celebration treat. Use:

> 3 cups flour
> 1 cup butter or substitute
> 1 cup sugar
> 1 egg
> 1 tablespoon vanilla

Cream the butter and sugar. Sift and measure flour, add baking powder, and sift again. Add to other ingredients and blend. Chill dough until it is firm enough to roll (several hours). Roll into a thin sheet on a floured board using a floured rolling pin. From here on, the children can go "creative." They can cut the dough with cookie cutters that have been dipped in flour or create their own patterns, which they cut from heavy cardboard. One side of the pattern is greased and placed on the dough; a sharp knife cuts around it. Remove the pattern, place the cookies on a lightly greased cookie sheet, and paint them with "cookie paint" before baking. Two cookie paint choices are given below.

For *egg yolk paint,* use

> 1 egg yolk
> ¼ teaspoon water

Blend well the egg yolk and water in a small bowl. Add food coloring. If it thickens, add more water.

For *milk paint:*

> Add: 2 drops of food coloring to
> several tablespoons of condensed milk
> Paint cookies with an artist's brush

Bake cookies in 425-degree oven for 5 to 7 minutes, or until light brown. Cool on wire rack.

Other cookie recipes are given in Chapter 18.

SPECIFIC CELEBRATION SUGGESTIONS

Because of "affirmative action" programs, there is much pressure in some localities not to relate to any of the holidays unless you relate to every last one of them. Teachers need to be aware of any policies in this regard, and to adapt their programs accordingly.

It is difficult, with very young children, to get away from holiday art activities, but so often, they are over-emphasized. A happy balance needs to be found. It is for these reasons that a limited number of ideas are presented here, and only for some of the more commonly celebrated days. Be sensitive to your particular group of children and include holidays of special significance to *any* of them. Hopefully, these ideas will trigger ideas of your own and suggest activities for the special days not mentioned.

Halloween

- Collage from pumpkin and other seeds.
- Black charcoal drawings on orange paper.
- Stuff paper bags with wadded newspaper, fasten with string, paint orange, add face with black construction paper.
- Trick or treat bags. Decorate grocery or shopping bags, punch two or four holes near top, reinforce with tape, and add handles of rope or ribbon.
- Masks. Design face masks from grocery bags or the large round ice cream cartons. Paper plates or construction paper can.be used to make masks for smaller children. Staple on elastic band or punch hole on each side to tie on yarn or ribbon.
- Crayon rubbing ghost. Make ghost shapes with string on heavy paper, eyes included. Cover with a sheet of lightweight paper and paper clip the two sheets together. With the side of a crayon, rub the top surface to bring out the ghost outline.
- Yarn ghosts. White yarn is glued on black paper, use paper reinforcer eyes or white paper circles.
- Spook and monster paintings, made with black tempera. Youngsters can first get the "feel" for it by practicing terrifying each other with menacing shapes and leers.

Halloween is mask-making time.

- Spooky music to draw to. Might use electronic music with inhuman strange sounds.
- Jack-o-lantern prints. Make jack-o-lantern shapes on the cut surface of a potato, print with orange paint on black paper.
- Crayon-resist ghost. With white candle or crayon, children draw ghosts on light paper. They can then dip their paper in the "magic wash"—a dishpan of thin black tempera paint.

Thanksgiving

- Popcorn pictures (popped corn glued on brown paper).
- Placemats, placecards for the feast table.
- Turkeys from pine cones, feathers, and pipe cleaners; turkeys from potatoes and colored toothpicks; turkeys from styrofoam eggs and colored pipe cleaners. Use 8–10 pipe cleaners, 2 for legs, 1 for head, and the others fashioned into loops for the tail.
- Avoid the all-too-common gimmick of tracing around the hand to form a turkey. This does little to encourage creative thinking. Nor would any of the activities described above if they are accompanied by adult-made models. When it is necessary to present a model, destroy it right away.

- Herb and spice design. After a session of smelling and tasting the many herbs associated with holiday cooking, sprinkle them over a design of wet glue on white construction paper.
- Put the emphasis on the *Thanks* of Thanksgiving by having the children draw or paint pictures of the many things they are thankful for.
- Put the emphasis on the *giving* of Thanksgiving and have the children create artworks for gifts.

Christmas

Starting such Christmas projects too far ahead is unwise for little ones; they get overstimulated and overanxious. This is the time to use glamorous materials—colored foil, sequins, silver and gold paint, glitter, velvet, and so on. Commercial things are so glittery at this season that to help the children's work look good beside them, the advantage of luxurious materials is desirable.

Christmas ideas are so numerous that we will mention just a few simple tree decorations that allow for creativity. Actually, a great many projects in previous chapters can be adapted for Christmas tree decorations.

- Baker's clay figures, paint and add glitter.
- Foil balls, bells, or shapes to be hung with pipe cleaners.
- Plastic crystals formed into designs on a cookie sheet and baked in the oven. (They are available from crafts shops.)
- Pine cones with paint and glitter.
- Styrofoam balls with sequin designs.
- Bells from decorated egg carton cups.
- Yarn forms that have been dipped in starch and dried on waxed paper.
- Animal shapes. Cut from double piece of cloth, blanket stitch around edge, stuff.
- Burlap stitchery ornament. Stitch design on burlap, back it with a second piece, stitch together, and stuff.
- Styrofoam cup bells. Loop string through bottom of cup for hanging, glue on braid or ribbon trim, or brush on glue, and sprinkle with glitter.

- Jar lid ornaments. Trace around lid on felt or construction paper and glue the circles to each side of lid. Edge of lid can be covered with ribbon or braid. Child can draw pictures on the paper or stitch designs on the felt before gluing the circles onto the lid. Glue on a yarn loop for hanging.

Do not forget to let the children decorate wrapping paper. One suggestion—Christmas designs carved into a cut potato. Brush on bright colored paint and stamp on shelf paper or newsprint.

Valentine's Day

- Valentine cards. The important thing is the originality contributed by the child. Patterns for hearts should not be made by the adult, but by the children. They can learn to fold the paper in half and draw the shape of a candy cane, fish hook or full ice cream cone, starting at the fold. Cut along the line and open and they have a heart. Provide colored construction paper, scraps of fabric and trim, bright colored foil, wrapping paper, paper doilies, braid, rickrack.

- Heart puzzle. Have the child put a message to a friend on the back of a heart and then cut the heart into a number of pieces, as many pieces as the adult thinks is right for that age group.

- Valentine tree. Set a large branch in a pail of sand or plaster and let the children hang on it as many different kinds of hearts as they can create.

Easter

For little children, Easter centers around eggs. Here are a lot of things to do with them.

- Hard cook eggs by covering them with heavily salted cold water—do not crowd in the pan—and bring to a boil. Turn off the heat, leaving the covered pan on the burner for 15 minutes. Immediately immerse the eggs in cold water. Fast cooling makes the shell easier to remove and helps avoid a greenish tinge around edge of yolk.

Dyeing eggs
- To dye eggs, use commercial food coloring (liquid or tablet) and 1 tablespoon of vinegar to each cup of dye.

202

Decorating Easter eggs.

- Make striped or plaid eggs by putting narrow masking tape strips or rubber bands around them. Dip in dye and remove tape or bands when eggs are dry.
- Crayon-resist eggs. Use light colored crayon to make design on egg, then dip in dye.
- Batik eggs (similar to above). Hold lighted birthday candle over egg and drip wax on it. Dip egg into dye. Drip on more wax and dip again.
- Marbled eggs. Marbling is explained in Chapter 17 on Printing.

Decorating eggs
- add felt pen drawings.
- glue on pictures of favorite comic book characters.
- glue on yarn designs, let liquid glue dry a little, and apply yarn.
- make a collage on egg with pasta, seeds, and beans.
- decorate with tissues, ribbon, sequins.

Egg heads
- Create animals and heads of people with the use of fabrics, fur, yarn, feathers, foil, and construction paper. For stands, use small bottle caps or make small cardboard cylinders. Toilet paper tube slices will work.

- Easter holiday tree. Decorated paper eggs, blown eggs, or papier mache eggs can be hung on the holiday tree described earlier.
- To blow egg—with darning needle, make a small hole in one end of the egg and a larger hole in the other. Blow through the small hole to empty the egg. Rinse out and air dry.
- Egg shell collage. Colored egg shells are saved from Easter and crumbled. Children can do this with their hands or the shells can be put in a plastic bag between sheets of waxed paper and crushed with a rolling pin or pounding tool. Make a design on paper with white glue and sprinkle the shells over it.

Birthdays

A child's birthday is his or her most special day. At school it can be celebrated in a very simple and satisfying way. A paper crown that says "Happy Birthday John/Susan" and a little play dough "birthday cake" with the right number of candles are all that are needed. The other children might draw or print a picture of the birthday child to give him or her as a gift.

At home, children might enjoy decorating their own birthday cakes. Family fun can include making hand prints and doing self-portraits. The child's body is traced on butcher paper, and he or she fills in the details. If this is done each year, it provides an interesting record of physical and artistic growth.

Expand on these lists with ideas of your own, keeping in mind the philosophy of creativity. Do not include a project that has just one best way to do it or must look just one way to be right.

Art develops best when it's an everyday activity
and not just connected with the holidays. (82)
HOOVER

closing thoughts

THE child who is both intelligent and creative remains society's most valuable resource. When we learn to work with him instead of against him, his talents may reward us in ways beyond our ability to imagine," say the Goertzels, in *Cradles of Eminence* (47).

As stated often in this book, art is a beautiful means to the end of greater creativity in children. When imagination and true expression are celebrated, the contribution to society is incalculable. In the words of E. E. Cummings, "To be nobody—but yourself—in a world that is doing its best, night and day, to make you everybody else—means to fight the hardest battle which any human being can fight, and never stop fighting."

Since art is autobiographical—an expression of oneself—children who have ample art opportunities and have their art affirmed have a lot of ammunition for the battle.

Genius At Work

The artist bent over his easel
And took up his palette and brush
He sketched in the curve of an outline
In colors all vivid and lush.

He splashed on a bit of ripe crimson.
He blended in scarlet and maize.
Then at length he leaned back from the canvas
And appraised it with critical gaze.

I watched him add high lights and shadows
With deftness and delicacy,
Convinced that no Reubens or Titian
Worked with greater absorption than he.

Slowly he turned and presented
That completed creation of his.
"See, Teacher! My picture's all finished.
Now, help me decide what it is."

ADELAIDE HOLL

The poem reiterates a central theme of this book—that children are much more process than product-oriented. Therefore, let's remember to keep our attention focused on what is important to them at this developmental stage—the creative process.

credits

The quotation on p. 7 is from Edmund Burke Feldman, *Becoming Human Through Art*—©1970—p. 1. It is reprinted by permission of Prentice-Hall, Inc., Englewood Cliffs, New Jersey.

Quotations from Viktor Lowenfeld and W. Lambert Brittain, *Creative and Mental Growth*—© 1963—and Viktor Lowenfeld, *Your Child and His Art*—© 1954—are used by permission of Macmillan Publishing Co., Inc.

Figures 1 and 2 on pp. 34 and 35 are from *Analyzing Children's Art* by Rhoda Kellogg. They are used by permission of Mayfield Publishing Company. Copyright © 1969, 1970 by Rhoda Kellogg.

Quotations from Blanche Jefferson, *Teaching Art to Children*—© 1969—are used by permission of Allyn and Bacon, Inc.

The excerpt from *Your Child's Self-Esteem* by Dorothy Briggs—copyright © 1970 by Dorothy Corkille Briggs—is reprinted by permission of Doubleday & Company, Inc.

The excerpt on p. 51 from Maude Ellsworth and Michael F. Andrews, *Growing with Art*—© 1960—is used by permission of Random House, Inc.

The excerpt on p. 74 from M. Dale Baugham, *Educator's Handbook of Stories, Quotes and Humor*—© 1963 by Prentice-Hall, Inc.—is used by permission of Prentice-Hall, Inc.

The list on pp. 89–90 from Charles E. Schaefer, *Developing Creativity in Children* is used by permission of D. O. K. Publishers.

The excerpt on pp. 169–70 from Sylvia Burns, *Bits and Pieces*—copyright 1967 by the Association for Childhood Education International—is reprinted by permission of Sylvia Burns and the Association, which is at 3615 Wisconsin Ave., N. W., Washington, D.C.

The excerpt on p. 179 from Nik Krevitsky, *Stitchery: Art and Craft*—copyright 1966 by Art Horizons, Inc.—is reprinted by permission of Van Nostrand Reinhold Company.

The quotation by E. E. Cummings from "A Poet's Advice to Students," *E. E. Cummings: A Miscellany*, edited by George J. Firmage, is used by permission of Harcourt Brace Jovanovich, Inc.

"Genius at Work," by Adelaide Holl, is used by permission of *Today's Education*, Journal of the National Education Association.

The excerpt from Kenneth Jameson's *Art and the Young Child* is used by permission of The Viking Press.

"Osborn's Checklist" from Alex F. Osborn's *Applied Imagination*—copyright 1953, © 1957, 1963 Charles Scribner's Sons—is used by permission of Charles Scribner's Sons.

bibliography and references

PART I
ART PRINCIPLES

See Bibliography, Part II, page 211, for books mentioned in the second half of the book, Art Practices.

A. Art Books

1. ALKEMA, CHESTER JORY, *Alkemas Complete Guide to Creative Art for Young People.* New York: Sterling Pub. Co., 1971.

2. BLAND, JANE COOPER, *Art of the Young Child.* New York: Museum of Modern Art, 1957.

3. BRUNO, LOUIS V., *Elementary Art Guide.* Olympia, Wash.: State of Washington, 1961.

4. CANE, FLORENCE, *The Artist in Each of Us.* New York: Pantheon, 1951.

5. CARSON, JANET, *It's Art Time: Handbook of Art Awareness Activities for Teachers.* Columbus, Ohio: Chas. E. Merrill, 1975.

6. COHEN, ELAINE PEAR, and RUTH STRAUS GAINER, *Art: Another Language for Learning.* New York: Citation Press, 1976.

6a. COLE, NATALIE ROBINSON, *Children's Arts from Deep Down Inside.* New York: The John Day Co., 1966.

6b. ————, *The Arts in the Classroom.* New York: The John Day Co., 1940.

6c. EDWARDS, BETTY, *Drawing on the Right Side of the Brain: A Course in Enhancing Creativity and Artistic Confidence.* Los Angeles: J. P. Tarcher, 1979.

7. ELLSWORTH, MAUD, and MICHAEL ANDREWS, *Growing with Art: A Teacher's Book.* New York: Random House, 1960.

8. FELDMAN, EDMUND BURKE, *Becoming Human through Art: Aestetic Experience in the School.* Englewood Cliffs, N.J.: Prentice-Hall, Inc., 1970.

9. HARRISON, ELIZABETH, *Self Expression through Art: An Introduction to Teaching and Appreciation.* Scarborough, Calif.: W. J. Gage Limited, 1960.

10. HENRI, ROBERT, *The Art Spirit.* Philadelphia: Lippincott, 1923.

11. JAMESON, KENNETH, *Art and the Young Child.* New York: Viking, 1965.

12. ———, *Primary School Art*. New York: Van Nostrand Reinhold Co., 1971.

13. JEFFERSON, BLANCHE, "The Color Book Craze," Bulletin F, Association for Childhood Education International, Washington, D.C., 1964.

14. ———, *Teaching Art to Children*. Boston: Allyn & Bacon, 1969.

15. KAUFMAN, IRVING, *Art and Education in Contemporary Culture*. New York: Macmillan Publishers, 1966.

16. KELLOGG, RHODA, *Analyzing Children's Art*. Palo Alto, Calif.: Mayfield Publishing, 1969.

17. KELLOGG, RHODA, and SCOTT O'DELL, *The Psychology of Children's Art*. New York: CRM-Random House, 1967.

18. ———, *What Children Scribble and Why*. Palo Alto, Calif.: National Press Publications, 1955.

19. LINDERMAN, EARL and DONALD HERBERHOLZ, *Developing Artistic and Perceptual Awareness*. Dubuque, Iowa: W. C. Brown, 1964.

20. LINDERMAN, EARL, *Invitation to Vision: Ideas and Imagination for Art*. Dubuque, Iowa, W. C. Brown, 1967.

21. LOWENFELD, VIKTOR, and W. LAMBERT BRITTAIN, *Creative and Mental Growth*. New York: Macmillan, 1964.

22. LOWENFELD, VIKTOR, *Your Child and His Art*. New York: Macmillan, 1954.

23. MENDELOWITZ, DANIEL M., *Children Are Artists: An Introduction to Children's Art for Teachers and Parents*. Stanford, Calif.: Stanford University Press, 1953/1963.

24. MERRITT, HELEN, *Guiding Free Expression in Children's Art*. New York: Holt, Rinehart and Winston, 1964.

25. MITCHELL, JOHN BLAIR, *Art—for Children's Growing, Bulletin #64*, Association for Childhood Education International, Washington, D.C., 1955.

26. PHILLIPS, BILLIE M., and VIRGINIA SUGGS BROWN, *The New "Discovery Technique for Art Instructors: An Innovative Handbook for the Elementary Teacher*. West Nyack, N.Y.: Parker Publishing, 1976.

27. REBER, JOEL, and CLYDE HUYCK, *Art Survival Guide for the Elementary Teacher*. Belmont, Calif.: Fearon, 1976.

28. RITSON, JOHN E., and JAMES A. SMITH, *Creative Teaching of Art in the Elementary School*. Boston: Allyn & Bacon, 1975.

29. RUBIN, JUDITH ARON, *Child Art Therapy: Understanding and Helping Children Through Art*. New York: Van Nostrand Reinhold Co., 1978.

30. SABO, JUDIE, and CHRISTINA HARRISON, *Art Expressions for Young Hands.* Palo Alto, Calif.: Page-Ficklin Publications, 1976.

31. SMITH, JAMES A., *Creative Teaching of the Creative Arts in the Elementary School.* Boston: Allyn & Bacon, 1967.

32. WACHOWIAK, FRANK, *Emphasis Art: A Qualitative Art Program for the Elementary School.* New York: Harper & Row, 1977.

33. WANKELMAN, WILLARD, WIGG, PHILIP, and MARIETTA, *A Handbook of Arts and Crafts for Elementary and Junior High School Teachers.* Dubuque, Iowa: Wm. C. Brown, 1961.

34. ZAIDENBERG, ARTHUR, *Your Child is an Artist.* New York: Grosset & Dunlap, 1949.

B. Non-art Books

35. BARKSDALE, L. S., *Building Self-Esteem.* Idyllwild, Calif.: The Barksdale Foundation, 1972.

36. BAUGHMAN, DALE, *Educator's Handbook of Stories, Quotes and Humor.* Englewood Cliffs, N.J.: Prentice-Hall, Inc., 1963.

37. BRIGGS, DOROTHY CORKILLE, *Celebrate Yourself: Making Life Work for You.* Garden City, N.Y. Doubleday, 1977.

38. ———, *Your Child's Self-Esteem: The Key to His Life.* Garden City, N.Y.: Doubleday, 1967.

39. CANFIELD JACK, and HAROLD C. WELLS, *100 Ways to Enhance Self-Concept in the Classroom.* Englewood Cliffs, N.J.: Prentice-Hall, Inc., 1976.

40. CONKLIN, ROBERT, *How to Get People to Do Things.* Chicago: Contemporary Books, Inc., 1979.

41. *Course of Miracles, Volume III, Manual for Teachers.* Tiburon, Calif.: Foundation for Inner Peace, 1975.

42. DEMILLE, RICHARD, *Put Your Mother on the Ceiling, Children's Imagination Games.* New York: Viking, 1967.

43. DINKMEYER, DON, and RUDOLF DREIKURS, *Encouraging Children to Learn: The Encouragement Process.* Englewood Cliffs, N.J.: Prentice-Hall, Inc., 1963.

44. EBERLE, ROBERT F., *Scamper: Games for Imagination Development.* Buffalo, N.Y.: D.O.K. Publishers, 1971.

45. ELKINS, DOV PERETZ, ed., *Glad to Be Me: Building Self-Esteem in Yourself & Others.* Englewood Cliffs, N.J.: Prentice-Hall, Inc., 1976.

46. GINOTT, HAIM G., *Teacher and Child: A Book for Parents and Teachers.* New York: Macmillan, 1972.

46a. GINSBERG, HERBERT, and SYLVIA OPPER, *Piaget's Theory of Intellectual Development.* Englewood Cliffs, N.J.: Prentice-Hall, Inc., 1969.

47. GOERTZEL, VICTOR and MILDRED, *Cradles of Eminence.* Boston: Little, Brown, 1962.

48. GOWAN, JOHN CURTIS, "How Parents Can Foster Creativity in Their Children," in *Teaching for Creative Endeavor* by William B. Michael. Bloomington, Ind.: Indiana University Press, 1968.

49. GOWAN, JOHN CURTIS, GEORGE D DEMOS, E. PAUL TORRANCE, eds., *Creativity: Its Educational Implications.* New York: John Wiley, 1967.

50. HENDRICKS, GAY, and THOMAS ROBERTS, *The Second Centering Book: More Awareness Activities for Children, Parents and Teachers.* Englewood Cliffs, N.J.: Prentice-Hall, Inc., 1977.

51. HENDRICKS, GAY, and RUSSEL WILLS, *The Centering Book: Awareness Activities for Children, Parents and Teachers.* Englewood Cliffs, N.J.: Prentice-Hall, Inc., 1975.

52. KNELLER, GEORGE F., *The Art and Science of Creativity.* New York: Holt, Rinehart, and Winston, 1965.

53. LOGAN, LILLIAN M., and VIRGIL J. LOGAN, *Design for Creative Teaching.* New York: McGraw-Hill, 1971.

54. OSBORN, ALEX F., *Applied Imagination: Principles and Procedures of Creative Problem Solving.* New York: Scribner's, 1963.

55. PARNES, SIDNEY J., *Creative Behavior Guidebook.* New York: Scribner's, 1966.

56. ———, *Creativity: Unlocking Human Potential.* Buffalo, N.Y.: D.O.K. Publishers, 1972.

56a. PIAGET, JEAN and BÄRBEL INHELDER, *The Psychology of the Child.* New York: Basic Books, 1969.

57. PURKEY, WILLIAM W., *Self Concept and School Achievement.* Englewood Cliffs, N.J.: Prentice-Hall, Inc., 1970.

58. READ, KATHERINE H., *The Nursery School.* Philadelphia: Saunders, 1960.

59. ROGERS, CARL, *On Becoming a Person.* Boston: Houghton Mifflin, 1961.

60. SCHAEFER, CHARLES E., *Developing Creativity in Children.* Buffalo, N.Y.: D.O.K. Publishers, 1973.

61. TORRANCE, PAUL E., *Creativity.* San Rafael, Calif.: Dimensions Publishers, 1973.

62. ———, *Encouraging Creativity in the Classroom.* Dubuque, Iowa: W. C. Brown, 1970.

62a. TURNER, THOMAS N., *Creative Activities Resource Book for Elementary School Teachers.* Reston, Va.: Reston Publishing Co., 1978.

63. WILLIAMS, FRANK E., *Classroom Ideas for Developing Productive-Divergent Thinking,* National Schools Project. Washington, D.C.: U.S. Office of Education, 1969.

64. WILSON, JOHN A. R., and MILDRED C. ROBECK, "Creativity in the Very Young," in *Teaching for Creative Endeavor* by William B. Michael. Bloomington, Ind., Indiana University Press, 1968.

PART II
ART PRACTICES

See Bibliography, Part I, for books mentioned in the first half of the book, Art Principles, and for books mentioned in the second half that are not in this Bibliography.

65. ASSOCIATION FOR CHILDHOOD EDUCATION INTERNATIONAL, "Bits and Pieces—Imaginative Uses for Children's Learning," Bulletin 20-A, Washington, D.C., 1967.

66. BOS, BEV, *Don't Move the Muffin Tins: A Hands-off Guide to Art for the Young Child.* Carmichael, Calif.: The Burton Gallery, 1978.

67. CARSON, JANET, *It's Art Time: A Handbook of Art Awareness for Teachers.* Columbus, Ohio: Chas. E. Merrill, 1975.

68. CHERRY, CLARE. *Creative Art for the Developing Child: A Teacher's Handbook for Early Childhood Education.* Belmont, Calif.: Fearon, 1972.

69. COLE, ANN et al., *A Pumpkin on a Pear Tree: Creative Ideas for Twelve Months of Holiday.* Boston: Little, Brown, 1976.

70. CROFT, J. DOREEN, and ROBERT D. HESS, *An Activities Handbook for Teachers of Young Children.* Boston: Houghton Mifflin, 1972.

71. CROSS, JEANNE, *Simple Printing Methods.* New York: S. G. Phillips, Inc., 1972.

72. DOWNER, MARIAN, *Discovering Design.* New York: Lothrop, Lee and Shepard, 1947.

72a. ELBERT, VIRGINIE FOWLER, *Potterymaking.* Garden City, N.Y.: Doubleday, 1974.

73. EMBERLEY; ED, *Great Thumbprint Drawing Book.* Boston: Little Brown, 1977.

74. ENTHOVEN, JACQUELINE, *Stitchery for Children: A Manual for Teachers, Parents and Children.* New York: Reinhold Book Corp., 1968.

75. FEININGER, ANDREAS, *Forms of Nature and Life.* New York: Viking Press, 1966.

76. FIAROTTA, PHYLLIS, *Snips & Snails & Walnut Whales: Nature Crafts for Children.* New York: Workman, 1975.

77. FRANK, MARJORIE, *I Can Make A Rainbow: Things to Create and Do for Children and Their Grown-Up Friends.* Nashville, Tenn.: Incentive Publications, 1976.

78. GETTINGS, FRED, *The Meaning and Wonder of Art.* New York: Golden Press, 1963.

79. GREENBERG, PEARL, *Children's Experiences in Art: Drawing and Painting.* New York: Reinhold Publishing Co., 1966.

80. GUYLER, VIVIAN VARNEY, *Design in Nature.* Art Resources Publications, 1970. Also, *Design in Nature,* new edition. Worcester, Mass., Davis Publications, Inc., 1970.

81. HOLLANDER, CORNELIA H., *Portable Workshop for Pre-School Teachers.* Garden City, N.Y.: Doubleday, 1966.

82. HOOVER, LOUIS F., *Art Activities for the Very Young—from 3 to 6 years.* Worcester, Mass.: Davis Publications, 1967.

83. JANSON, H. W., and DORA JANE JANSON, *The Story of Painting for Young People.* New York: Harry N. Abrams, 1952.

83a. JENKINS, PEGGY, *The Magic of Puppetry: A Guide for Those Working with Young Children:* Englewood Cliffs, N.J. Prentice-Hall, Inc., 1980.

84. JOHNSON, PAULINE, *Creating with Paper.* Seattle, Wash.: University of Washington Press, 1951.

85. KAMPMANN, LOTHAR, *Creating with Crayons.* New York: Reinhold Book Corp., 1968.

86. ———, *Creating with Printing Material.* New York: Van Nostrand Reinhold Co., 1969.

86a. KATZ, MARJORIE P., *Fingerprint Owls and Other Fantasies.* Philadelphia: M. Evans, 1972.

87. KESSLER, LEONARD, *I Made A Line.* New York: Wonder Books, 1962.

88. ———, *What's In A Line.* New York: William R. Scott, 1951.

89. KIRN, ANN, *Full of Wonder.* Cleveland, Ohio: World Publishing, 1959.

90. KLONSKY, RUTH L., *Art Lessons that Mirror the Child's World.* West Nyack, N.Y.: Parker Publishing, 1975.

91. KREVITSKY, NIK, *Stitchery: Art and Craft:* New York: Reinhold Publishing Co., 1966.

92. LALIBERTE, NORMAN, RICHEY KEHL, and ALEX MOGELON, *100 Ways to Have Fun with an Alligator and 100 Other Involving Art Projects.* Blauvelt, N.Y.: Art Education, Inc., 1969.

93. LALIBERTE, NORMAN, and ALEX MOGELON, *Painting with Crayons: History. and Modern Techniques.* New York: Reinhold Publishing Co., 1967.

94. LARSON, KATHERINE A., and FREDERICK A. RODGERS, *Let's Make Something with Shapes and Colors.* Champaign, Ill.: Continuing Education Publishing Co., 1978.

95. MACAGY, DOUGLAS and ELIZABETH, *Going for a Walk with a Line: A Step into the World of Modern Art.* Garden City, N.Y.: Doubleday, 1959.

96. MATTIL, EDWARD L., *Meaning in Crafts.* Englewood Cliffs, N.J.: Prentice-Hall, Inc., 1971.

97. MEILACH, DONA Z., *Creating Art from Anything: Ideas, Materials, Techniques.* Chicago: Reilly and Lee, 1968.

98. MENLOVE, COLEEN KENT, *Ready, Set, Go!* Englewood Cliffs, N.J.: Prentice-Hall, Inc., 1978.

99. MORMAN, JEAN MARY, *Wonder under Your Feet.* New York: Harper & Row, 1973.

99a. NICOLAIDES, KIMON, *The Natural Way to Draw.* Boston: Houghton Mifflin, 1941.

100. OTA, KOSHI et al., *Printing for Fun.* New York: McDowell, Obelensky, 1960.

101. PARRAMON, J. M., *How to Be Creative with Paper.* Hertfordshire, England: Fountain Press, 1974.

102. PITCHER, EVELYN GOODENOUGH et al., *Helping Young Children Learn.* Columbus, Ohio: Chas. E. Merrill, 1979.

103. PLATTS, MARY E., *Create: A Handbook of Classroom Ideas to Motivate the Teaching of Primary Art.* The Spice Series. Washington, D.C.: Educational Services Inc., 1977.

104. RAINEY, SARITA R., *Weaving without a Loom.* Englewood Cliffs, N.J.: Prentice-Hall, Inc., 1966.

213

105. RANDALL, ARNE W., and RUTH ELSIE HALVORSEN, *Painting in the Classroom.* Worcester, Mass.: Davis Publications, 1962.

105a. RIEGER, SHAY, *Gargoyles, Monsters and Other Beasts.* West Caldwell, N.J.: Lothrup, Lee and Shepard, 1972.

106. ROCKWELL, HARLOW, *Printmaking.* Garden City, N.Y.: Doubleday, 1973.

107. ROTTGER, ERNST, *Creative Clay Design.* New York: Reinhold Publishing Co., 1963.

108. ———, *Creative Paper Design.* New York: Holt, Rinehart, and Winston, 1961.

109. SATTLER, HELEN RONEY, *Recipes for Art and Craft Materials.* West Caldwell, N.J.: Lothrop, Lee and Shepard, 1973.

109a. SCHEFFER, VICTOR B., *The Seeing Eye.* New York: Scribner's, 1971.

110. STROSE, SUSANNE, *Potato Printing.* New York: Sterling Pub. Co., 1968.

111. *Sunset Children's Crafts: Fun and Creativity for Ages 5–12.* Menlo Park, Calif.: Lane Publishing Co., 1977.

112. TODD, VIVIAN, and HELEN HEFFERMAN, *The Years before School.* New York: Macmillan, 1964.

113. WEISS, HARVEY. *Paper, Ink and Roller-Print Making for Beginners.* Reading, Mass.: Young Scott, 1958.

114. Whitman Creative Art Book Series *(Painting #1, #2, #3, Print Art #1, Paper Art #1, Papier Mache #1, Stitchery #1, Constructing #1).* Racine, Wis.: Whitman Publishing, 1966.

115. WISEMAN, ANN, *Making Things: The Handbook of Creative Discovering.* Boston: Little, Brown, 1973.

116. YAMADA, SADAMI, *New Dimensions in Paper Craft.* Rutland, Vt.: Japan Publications, 1967.

117. YUSKO, AARON ALLEN, *Art: A Learning Experience for the Very Young.* Boulder, Col.: Pruett Publishing, 1974.

118. ZARCHY, HARRY, *Mobiles.* New York: The World Publishing Co., 1966.

index

Please remember that this is a library book,
and that it belongs only temporarily to each
person who uses it. Be considerate. Do
not write in this, or any, library book.

DATE DUE